DISCARD

SOCIETY: REVOLUTION AND REFORM

SOCIETY

REVOLUTION AND REFORM

Proceedings of the
1969 Oberlin Colloquium in Philosophy

EDITED BY

Robert H. Grimm

AND

Alfred F. MacKay

The Press of
Case Western Reserve University
Cleveland & London / 1971

Contents

Preface

Symposium
 JEROME B. SCHNEEWIND 3
 Moral Progress
 JOEL FEINBERG 19
 Comments

Symposium
 ARNOLD S. KAUFMAN 33
 Democracy and Disorder
 FELIX E. OPPENHEIM 53
 Comments

Symposium
 RONALD M. DWORKIN 59
 Philosophy and the Critique of Law
 GERALD C. MACCALLUM, JR. 82
 Comments

Symposium
 DAVID BRAYBROOKE 93
 Revolution Intelligible or Unintelligible
 MARSHALL COHEN 119
 Comments
 DAVID BRAYBROOKE 129
 Reply

Preface

This volume is the Proceedings of the tenth annual Oberlin Colloquium in Philosophy (1969). The Colloquium is sponsored by the Department of Philosophy of Oberlin College to provide an opportunity for the presentation and close, extended discussion of new work in philosophy. The 1969 Colloquium included four symposia, each consisting of a principal paper and commentary. All are published here for the first time.

In the first symposium Jerome B. Schneewind addresses himself to the question, "Can there be progress in the substance of our moral beliefs or commitments as such?" He argues that there can be real moral progress; that it may come about either through piecemeal procedures of reform, or more abruptly through revolutionary procedures; that the rise of Benthamism in Great Britain provides an historical paradigm of moral progress brought about through "revolutionary" procedures; and that there is a clear parallel between his two kinds of progress with respect to morality and two kinds of progress which may be discerned in scientific knowledge. Joel Feinberg, in his comments, agrees that moral progress is possible and has occurred in the past. However, he argues that in order for a change to count as revolutionary it must be: (1) sudden, (2) drastic, and (3) fundamental. In connection with the third of these criteria he finds difficulties with Schneewind's analogy between morality and science, and expresses some non-cognitivist reservations about the notion of "moral discoveries."

In the second symposium Arnold S. Kaufman argues that the tactic of disorder in pursuit of political goals is as legitimate in democracies as in non-democracies. He does not argue in defense of disorder as a political tactic, only that there are no special reasons to reject its use in a democracy. To the consistency argument that if anyone in a democracy is granted the moral right to practice disorder then everyone must be granted this right, Kaufman re-

sponds that this holds for any society, hence provides no objection to his thesis. In addition, Kaufman considers three main sorts of special reasons why democracy is often thought to imply an obligation to refrain from disorder: (1) the intrinsic virtues of democratic processes, (2) the power of democratic processes to produce right decisions, and (3) the availability of a peaceful electoral route to change in democracies. Kaufman argues that none of these reasons provides a basis for any plausible argument in support of the claim that the tactic of disorder is never justified in a democracy. Felix E. Oppenheim, despite his general agreement with Kaufman's rebuttals of the arguments against disorder in a democracy, offers two main reasons why he still concludes that in general it is morally wrong to accept disorder as a political tactic in a democratic system. He argues that (1) Kaufman has not shown the consistency argument to be unsound for democracies; and that (2) the negative utility of disorder is bound to be so great that even when there is little probability that disorder will be more harmful than peaceful behavior, it is rational to take the course of peaceful behavior.

In the third symposium, Ronald M. Dworkin is concerned to show how radical critics who dispute the value of law as an abstract institution and conservative critics of law enforcement share a common assumption that these disputes necessarily involve a trial of the value of law. Dworkin maintains that this assumption is mistaken, and that it depends upon one particular theory about the nature of law, the positivist theory set out in different forms by John Austin, Hans Kelsen, and H. L. A. Hart. Dworkin claims that according to this theory the law is morally neutral, being a set of rules adopted in accordance with stipulated constitutional procedures. Dworkin outlines an alternative theory of law which centrally involves the notions that some moral rights and obligations arise out of social conventions or institutions, and that judgments of such rights and obligations play a role in legal reasoning. He maintains that this is a better theory of law than positivism, and considers how the disputes of the critics of law and of law enforcement would

differ if this theory rather than the positivist theory was generally accepted. Gerald C. MacCallum Jr. is attracted to Dworkin's claim that decisions of complex and controversial lawsuits involve bringing together many strands including moral philosophy, but is troubled by Dworkin's claim that a judge may work with and be guided by the moral conventions of his community. MacCallum raises two questions at the start: (1) How are we to test the claim that appeals to moral conventions have the role Dworkin ascribes to them in legal systems? (2) How are we to test claims about what the moral conventions of a given community are? Further, MacCallum argues that Dworkin does not sufficiently specify the kind of hard case in which appeal to moral conventions is appropriate, and that this yields the result that we have no way of knowing whether appeals to moral conventions are uniformly subordinate to appeals to legislation and to precedent. In general, MacCallum asks, how are appeals to legislation, to precedent, and to moral conventions put together in a legal system? And he suggests that an answer to this question is important for judging to what extent Dworkin's position might provide an accommodation to both radical and conservative critics and law enforcement.

In the final symposium David Braybrooke discusses "the different ways in which revolutions may be intelligible or unintelligible," with particular emphasis upon the possibility of providing a coherent interpretation of the revolutionary's demand for total change. He locates a number of intellectual features of revolutionary thinking, including "an emotional predisposition to total denunciation," "the demand for a story that adds everything up" in human history, and "the predisposition to approach the question of social change in the spirit of religious prophecy," which conspire together in different ways to produce what he calls the Extravagances of Total Change. He concludes that revolutionaries would do well to avoid extravagant demands for total change, thereby improving their chances of predicting and explaining the effects of the changes they do demand, and of justifying such changes by appeal to a retained selection of present values. Marshall Cohen, in his comments, ar-

gues that no serious revolutionary thinker has been committed to the extravagant interpretation of the demand for total change.

The authors for the Colloquium in 1969 came from seven universities: Schneewind from the University of Pittsburgh, Feinberg from Rockefeller University, Kaufman from the University of Michigan (he has since moved to the University of California at Los Angeles), Oppenheim from the University of Massachusetts, Dworkin from the Yale Law School (he has since gone to University College, Oxford), MacCallum from the University of Wisconsin, Braybrooke from Dalhousie University, and Cohen from Rockefeller University. The members of the Department of Philosophy of Oberlin College are indebted to the authors for their contributions and to the other philosophers who attended the Colloquium for their participation. They also wish to thank Oberlin College for its continuing support of the Oberlin Colloquium in Philosophy.

R. H. G. and A. F. M.
for the Department of Philosophy
Oberlin College

SOCIETY: REVOLUTION AND REFORM

Moral Progress

JEROME B. SCHNEEWIND

Moral criticism of society has often, if not always, involved criticism of the morality of society. In our own times, at least, the two are inseparable. Not just the institutions, laws, procedures, etc., of Western society are under attack, but a large range of aspects of the morality conceived to be embedded in them, or used to support them, are being criticized as well. Some of the criticism is articulate and overt. The youth of the West, we are told, find the morality of their parents repressive and hypocritical and have no hesitation in saying so. Claims are made to the effect that the morality of the middle classes, whatever its professions, rests upon subordination of certain groups to others—of blacks to whites, of pre-industrial to industrial nations; and this subordination receives covert sanction from a morality which must be condemned for giving it. Black people in our own country claim that the so-called American morality fosters an attitude of condescension and paternalism toward them. There is some sign of a resurgence among women of renewed objection to the allegedly lower status allotted them in the morally acceptable roles of our times. Articulate criticism is not the only kind involved here. Innumerable experts on the younger generation, on minority groups, on criminals, on education, on child-rearing practices, and on rehabilitation work, tell us repeatedly of the alienation, the anomie, the dropping-out, the apathy, the self-hatred, and the identity problems that arise from the feeling that the society structured around our traditional moral values is no longer viable or acceptable. And if it is indeed a fact that our morality fails, to a larger extent than previous moralities, to provide a focus for community, and for a sense of membership in the central group, then this is itself a serious criticism of that morality. Within the body of

those who feel no such large-scale disagreements with our morality, there are nonetheless bewilderments and disagreements. Technology, now as always, provides occasion for new and difficult decisions to be made. Less directly and less noisily, the advance of science continues to encroach on assumptions behind traditional morality and to increase a sense of uneasiness about it. We need not, in response to this, scream "Crisis!" and flee to the first shiny new *Weltanschauung* that offers itself as an all-encompassing shelter from the rain of problems besetting us. But we may at least pause on occasion to ask some general, large-scale questions about the possibilities of resolving difficulties raised by this storm.

I propose therefore to consider some aspects of the problem of moral progress. Moral progress is, I suppose, what we hope for as a result of the criticism of morality. But there are different ways in which one may think of it; and I shall not discuss all of them. One may, for instance, consider moral progress simply in terms of the improvement of individual morality, as the slow development of this man and that toward some ideal of moral perfection. If one believes that moral knowledge is easy to attain and hard to live up to, as Kant did, it will be this sort of progress that concerns one. And it will concern one all the more if one believes, as many religious thinkers have believed, that social and political institutions cannot be improved very much, or that it does not really matter very much whether they are or not. Again, one may consider moral progress to be equally possible for the laws and structures of our common life. Judging them, as one judges individuals, in the light of an accepted morality, one may work to improve them, or to abolish them and replace them with something clearly better. Both of these sorts of change might be considered as moral progress, and both may be envisaged as a result (in part) of the criticism of morality. Since one might consider one's commitment to the morality by which improvement is judged to be either rational or emotional, belief in the possibility of this sort of moral progress is independent of one's beliefs as to the 'cognitive status' of morality.

Critics of the morality of society have not, however, always been content with these types of criticism. They have raised a further

question about the acceptability of the accepted morality of their times. "The morality of the first ages," wrote J. S. Mill,

> rested on the obligation to submit to power; that of the ages next following, on the right of the weak to the forbearance and protection of the strong. How much longer is one form of society and life to content itself with the morality made for another? We have had the morality of submission, and the morality of chivalry and generosity; the time is now come for the morality of justice. [*Subjection of Women* (New York, 1965), p. 259]

More recently, from a well-known non-cognitivist, we have the following comment: "The meta-ethical philosopher. . . . thinks of meta-ethics as analogous to the logic of science, whereas it is at least arguable that the conceptual investigation of our ordinary moral notions is more like the philosophy of magic and witchcraft (if there is such a branch of philosophy)." (J. J. C. Smart, *An Outline of a System of Utilitarian Ethics*, [Melbourne, 1961], p. 1). The suggestion contained in this remark of Smart's—which might be put emphatically by saying that it is possible we are living in the Dark Ages of morality—underlies Mill's concern about the morality of his society. And it raises in acute form the question about moral progress which I should like to consider: can there be progress in the substance of our moral beliefs or commitments as such? This may seem to be a point on which the cognitivist and non-cognitivist will have to give different answers; but at least they can raise similar questions. The cognitivist—and I should perhaps say that I count myself among that vaguely delimited crowd—may put the question by asking if there can be progress in moral knowledge. The non-cognitivist can, I think, raise an analogous problem by asking if there can be a set of moral attitudes or commitments toward which he would feel a greater degree of approval than he feels toward the moral attitudes or commitments he now has.

The question is not without practical importance. It is obvious that human beings do not live up to their ideals and principles in every action of their lives, and our standards enshrine this unsurprising imperfection. We do not expect everyone to be perfectly fair and kind, to keep all his promises and always to give his tithe to charity. Nor can we expect institutions and societies to be perfect

in terms of the ideals and ends in the light of which they operate or for the securing of which they were framed. Given an average extent of failure-to-be-perfect, however, it may be possible to work for improvement, not by preaching saintliness to men and incorruptibility to society, but by bringing about progress in the substance of the morality which men so reliably fail to live up to.

One objection may immediately be made to the possibility of progress in the content of our moral beliefs or commitments. "If such progress is conceivable," it may be said, "it must at least be radically different from the kind of progress possible in scientific knowledge. For in morality we do not discover new truths. The basic principles or laws or approvable commitments are as old as mankind. That one must not kill wantonly, must respect the integrity of persons, must honor one's contracts—there is no room here for progress. And everything else is a matter of applying fundamental principles like these to changing social and personal circumstances. Therefore, innovation is at most derivative in morality; but this is not so in science."

Two points may be made in reply to this. (1) It is not altogether clear that it is plainly and simply accurate. Much of what now seems to us to be central to morality has not seemed so to all peoples at all times. We now, for instance, distinguish quite sharply between the worth a man may have or acquire because of his strength of will or character in deliberately trying to do what is right, and the worth he may have or acquire because of achievements due to his equipment, whether that be social—his wealth and status—or personal—his intelligence and strength. This distinction has not always been made as clearly as we would wish to make it, and if we think the distinction a valid one, we must think that we have made important progress in our moral thought in at least this respect. Moreover, it is not certain that ancient peoples did accept all of what we take to be basic principles, or accepted them as having the universal scope we now think of them as having. The treatment of women, slaves, and foreigners in some ancient—or not so ancient—communities may be taken to show either that moral norms

were not thought to require the same treatment for these groups as they required for male citizens, or that, though the norms required the same treatment of all humans, members of these groups were not thought to be fully human. If the former is true, the principles accepted in the morality of the ancient communities were not the same as our principles. In the latter case, there is a conceptual problem: can a system of norms which involves the denial of human status to human beings on the ground that those beings are not of one's sex, tribe, color, etc., be counted as a fully developed moral system? It seems doubtful whether these norms are as yet distinguished entirely from tribal laws, customs, and taboos. In either case, then, it may have to be allowed that moral discoveries have been made in the course of history; and if they have been made in the past, there seems little basis for the claim that they have all been made and that there is no room for further discoveries. (2) Even if we suppose that in fact there has been no time when human groups have been without knowledge of the basic moral norms which we today also accept, the conclusion that progress is impossible does not follow. Morality, after all, cannot be restricted to those duties to return borrowed books, to practice your trumpet softly, and to keep (or not to keep) promises made in private to dying progenitors of profligate offspring which have figured so largely in academic debates on ethics. It must be understood in a far broader way, as including all the normative aspects of socially defined roles which give shape to our expectations and our plans, and from which, as starting points, most of us try to create whatever individuality our lives will contain. If some small set of moral principles has always served as the basis for this structure of requirements and ideals, there has also been endless opportunity for creativity and inventiveness in the details. Might we not consider these basic principles to be analogous to certain plain and obvious facts about the universe which every scientific theory must accept? Science does not consist only in the discovery of new and startling facts, and in the overthrow of false beliefs. It consists in large part in making more intelligible and coherent our understanding of

facts which can come as a surprise to no one. A new scientific theory may extend our grasp to new areas of the universe, but it will do so in part by incorporating our older understanding, with whatever modifications, not by rejecting it outright. If the same possibility holds for morality, then the objection under consideration fails to show that progress in our moral beliefs cannot occur.

Another objection must be considered. "The judgment that one code is morally superior to another, so that progress has occurred when a society or individual abandons one and adopts the other, is itself a moral judgment," it is said, "and a moral judgment must be passed from the standpoint of the morality of the man who passes it. How then can one hope to pass a significant judgment on the question whether one has been progressing in one's own moral development, or on the question whether one's society, so far as one identifies with it, has made moral progress? One can easily condemn those—oneself included—who do not live up to the demands of morality. But the demands of morality are its substance, and unless the morality is internally self-contradictory it will not contain grounds for self-condemnation. Yet self-condemnation is what would be involved in declaring that one's own morality was at a lower stage of moral progress than some other. But if the morality is self-contradictory it can equally well come out with a self-endorsement. More seriously, to say that one's morality is such-and-such is not merely to describe the principles in accordance with which one finds oneself acting—to describe, as it were, one's principled habits. It is to indicate the principles one is prepared to endorse and defend. To say that some other morality is higher or more advanced than one's own is to endorse it also. If the two conflict, as they must if there is to be any point in contrasting them, then one is contradicting oneself in saying that some morality not one's own is more advanced than one's own. But then the claim that one's own morality is at the forefront of moral progress is itself simply vacuous." We may note that this objection does not touch the critic of society who does not accept the social morality as his own; but more needs to be said about that. It seems to prove, if it proves anything,

far too much. For it seems to show that one *must* think of one's own moral beliefs as beyond improvement or as perfect. And this is surely paradoxical. Not only may we have a general willingness to consider our moral beliefs open to correction and improvement —like our other beliefs—but we may come to think or feel that specific commitments or attitudes of our own are not all that they ought to be. This is an ordinary and normal part of the operation of any reasonably developed morality. Some aspects of our web of beliefs impinge on other aspects, and under new circumstances, new sorts of consequences of maintaining a particular standard, or using a certain moral category may reveal a latent conflict within our beliefs. We may then come to feel doubtful as to the validity of our past practice, without being clear as to what should replace it. Because in these circumstances one is in a position to see how genuine progress could be made in one's own moral beliefs, one is also in a position to judge non-vacuously that one's present commitments are more advanced than any others one could adopt. To reply that when one is in doubt about a particular moral norm or ideal that norm or ideal cannot count as part of one's own morality is to trivialise the claim that one cannot non-vacuously judge one's own beliefs to be an advance on any other beliefs. For the point then becomes a purely verbal one. "Only norms about which one has no doubts are part of one's code; the instant doubts arise about a norm it ceases to be part of one's code; and therefore finally abandoning it is not abandoning any part of one's own code." But this view of morality as actually held is unhelpful. At best it focuses our attention on the question of the grounds for saying that our morality needs improvement, or for judging that we have made progress in our system of moral beliefs.

I should like to suggest that we distinguish two types of procedure leading at least potentially to moral progress, and involving dissimilar though not wholly different grounds for demanding and assessing it. One is the normal, piecemeal, bit-by-bit reform from within an accepted morality. It must form as much a part of the scheme of things on a non-cognitivist as on a cognitivist analysis of

morality. Vacillating, ambivalent, and timid feelings, no less than rigid or compulsive attitudes, can hamper action and confuse judgment; and these would be the emotivist analogues, I suppose, of contradictory or repeatedly conflicting rules and principles, and of impossibly puritanical or ascetic ones. There is no particular philosophical problem lurking in our ability to see that part of our morality deserves one of these or perhaps other similar types of condemnation and of our ability to attempt to rectify the faulty part. No more are there puzzles in our ability to extend our principles or our attitudes to cover new types of situations. It is in these familiar and unexciting ways that normal progress is made in the content of our moral beliefs. But I should like to argue that a second type of progress is also conceivable, and possibly quite important. It is more thorough-going and radical than the piecemeal reform procedures of everyday life, though it rests on some of the same grounds. Though the name may suggest too great a difference between the two types of procedure for attempting to secure progress, I shall contrast it with the reform procedure by calling it the "revolutionary" procedure.

Perhaps the best way to indicate what I mean by the revolutionary procedure for procuring moral reform is to discuss a situation that at least came close to being an instance of it. And the only one which time and my knowledge permit me to discuss is the situation in Great Britain during the Regency and the early Victorian period. The years from the start of the nineteenth century to the accession of Victoria were filled with intense debate about the morality of British society. Religiously motivated reformers worked to alter the habits of sexual profligacy, drunkenness, profanity, and political indifference of the upper classes; the anti-slavery campaign was at fever pitch; agitation for political emancipation of Catholics and other minority religious groups aroused fierce passions; clamor from the working classes, suffering from a variety of economic, political, and social distresses, was loud; and demands for honest government and for enfranchisement for the middle classes increasingly gathered strength. Much of the propaganda for these various

movements was of what I have called a reformist kind. The evangelical religious leaders, for example, were calling for a return to the purity and love inculcated by the Christian norms and ideals which the society explicitly avowed, and condemning slavery in the name of the same teaching. They were calling, in other words, for a deeper and more thorough-going application of already accepted standards, confident that this would lead to the realization that much of what was accepted as—morally speaking—either venial, or neutral, or quite compatible with those norms would then be seen to call for condemnation and alteration. Theirs was a deeply conservative attempt at moral progress, and was recognized as such by most people at the time. By contrast, the Benthamites, who were heavily involved in many of the reform movements of the age, were felt to be advocating a dangerously revolutionary outlook. This was not due entirely to their political activity or to the specific moral points on which they differed from their critics. It was due in part to the fact that their general ethical view involved a transformation of morality, a transformation which, from the traditional point of view, looked like a degradation.

Bentham's general position is well known, and a brief reminder of his main theses will suffice for our purposes. Benthamism is a radical form of consequentialism. The basic bearers of good and evil are certain states of affairs, which may be brought about either by human actions or by non-human, natural, causes. Some of these, which Bentham called pleasures, are naturally good, and others, called pains, are naturally evil, simply because men as they are like some and dislike the others. Every other evaluational and moral predicate is defined in terms of these basic ones. Human actions are said to be right in proportion as they produce good states of affairs, wrong in proportion as they produce bad states; and the act that ought to be done is the act which of the alternatives open to the agent at the time of decision would, or would most probably, produce the highest proportion of good over bad consequences. Bentham views intentions as causes of actions, and holds that they are good if the actions they produce or normally produce are right,

bad if the actions they lead to are wrong. Motives and character traits are treated in similar fashion: motives are considered as causes of intentions, and are to be assessed directly in terms of the value of the intentions they produce and indirectly, therefore, in terms of the acts, and finally of the consequences, to which they lead. One effect of this analysis of morality is to treat morality in general as the means to the promotion of a good which is definable independently of it. As a result of this, the goodness which human beings can acquire as moral agents is purely instrumental. A good man is essentially one who is good for the production of pleasure. To be *morally* good, of course, the man must produce good deliberately and voluntarily; but the distinction between voluntary and non-voluntary acts is itself justified by the fact that it enables us to distribute rewards and punishments where they will be most effective in stimulating production of good and retarding production of evil. A second effect of the Benthamite analysis of morality is that it makes all values commensurable. By analyzing all claims about rights, duties, obligations, virtues, etc., as claims about amounts of a measurable quantity, Bentham thought he had provided for a scientific method of reaching testable decisions on any moral question. He claimed that his theory therefore offered a more fully rational morality than any that did not supply an equally comprehensive decision procedure. His view, unlike any less fully rational one, could be used, and was intended, for the purpose of rectifying the confused inherited morality of common sense—that amalgam of the results of superstition, group interest, custom, prejudice, and, just occasionally, truth. It was to be one of the great instruments in the progress of moral knowledge.

Noting some of the points at which nineteenth-century critics objected to Benthamism will help to bring out why I wish to use it to give an idea of a revolutionary instrument of moral progress. It is clear, to begin with, that if—as some critics thought—Benthamism was meant to subvert the entire fabric of civilized morality by sanctifying a bestial pursuit of pleasure, it did not aim at doing so by outright denial of the major duties and virtues acknowledged

in England at the time. Quite the contrary: the Benthamites seem to us almost painfully conventional in most of their moral judgments concerning family, law and order, industriousness and thrift, property, respectability, and a host of other matters. They differed from their religiously-oriented critics here no more, or not much more, than those critics differed among themselves. Benthamism, then, we may say, incorporated the great central core of moral belief which no one was prepared to doubt or abandon. But in several respects it gave it quite a different significance than it was understood to have among the opponents of Benthamism. Thus morality, in the Benthamite view, is detached from any links, conceptual or contingent, with religious beliefs or with metaphysical views of a religious nature. To see earthly life as a probationary period, and our earthly acts and successes as at most signs of inner qualities whose worth could be known directly by God; to consider that achievement here has therefore no intrinsic significance; to see moral failure as alienating one from a loving Being, and moral improvement as bringing one closer to Him; to see the point and focus of morality as being the improvement of individual souls, and to see the human soul as somehow a unique phenomenon within nature and consequently the potential possessor of an unique kind of value—all this, if one was a thorough Benthamite, could no longer be accepted. And so, to the consternation of the orthodox, all the aspects of the common morality that depended on such beliefs were to be rejected. One reason why Benthamism is a prototype of a revolutionary procedure for moral progress is its abandonment of sections of ordinary morality, not because the specific contents are morally erroneous and open to improvement in the light of greater moral insight, but because these sections no longer are relevant. Benthamism did not offer an alternative view of duties relying on religious matters, it simply dropped the subject. Consequently, what remained of morality assumed far greater weight than it would otherwise have carried. Common-sense morality had always stressed the goodness of working for the well-being of others, had sometimes allowed the breaking of rules when misery could

be averted by so doing, and had granted some importance to actually alleviating the earthly condition of the poor. Once these aspects of morality were no longer counter-balanced by other-worldly moral concerns, it was far easier to interpret them in the new light of the Benthamite principle—that all moral duties were derivative from the duty of increasing happiness. The rest of the central core of morality could also take on a new look, when seen rather as a fairly well-tested set of devices for procuring human well-being than as a matter of divinely ordained rules or eternal verities. Benthamism was morally revolutionary in that it gave a basically different understanding of the point of morality to those who accepted it. It thereby influenced the operation even of the traditional duties and rules to which it was committed in common with the older outlook: their degree of rigorousness, their status vis-à-vis other rules and duties, the grounds for making exceptions to them, would all have been changed by putting them into the context of Benthamism.

Moralists of the non-Benthamite persuasions frequently challenged the assumption implicit in this last assertion—that Benthamites shared some moral beliefs with non-Benthamites. Their challenge was based on the claim that the meaning of moral terms was seriously distorted by the Benthamite analysis. It could not be said, critics asserted, that the view really allowed for the existence of morality, properly speaking, at all. Since I do not have an adequate theory of meaning—to say nothing of a theory of change of meaning—it would be presumptuous to try to decide whether this charge was true or not. On the one hand, religious moralists seem to have felt that there were some meaning-links between the moral and the religious vocabulary, and these the Benthamites certainly removed. On the other, the central terms of morality were used by the innovators in ways at least closely analogous to the ways the traditionalists used them. Benthamite usage preserved many of the intra-moral conceptual linkages of the older meanings, e.g., the link between consciously choosing the right or obligatory act and deserving to be praised, or at least not condemned. And many moral assertions which the older moralists made would have been accepted

by the Benthamites, as we have seen. Thus, the question of whether or not the Benthamites' theory required an alteration in the meaning of moral terms is vexed. But this is in itself an indication of why the Benthamite theory may count as revolutionary rather than simply reformist. The Benthamite analyses of the meanings of moral terms were dictated by the demands of the moral reorientation they were attempting to bring about. Descriptive accuracy was thus less a consideration for them than it was for those who were attempting to offer intellectual defenses of the moral fabric as it already existed. It is no accident that Bentham himself should have been so concerned with clarifying and criticizing ordinary language; he saw even its commonest terms as loaded with implications which were quite contrary to the moral view he was advocating. He was thus forced to adopt a position which left room for the charge that he was trying, not to reform morality, but to replace it with something else.

Yet his own view of the matter was that he was offering a way of doing what any morality had to do which was better than the way offered by the existing moral code. And the making of some claim along these lines is one more mark of a revolutionary procedure for achieving moral progress. It is clear that acceptance of this sort of procedure for improving moral commitment involves giving up a good deal of what one has taken for granted, or thought to be central, in morality. What can be the warrant for this? In what I have called "reformatory" procedures, progress is conceptually unproblematic, since it requires primarily the further application and more careful use of accepted norms. But as a revolutionary procedure may eliminate a number of accepted norms, it clearly cannot rely on them for its justification, nor need it be true that the remaining principles and ideals within the accepted code call for their removal. Benthamism rests on the view that morality must provide coherent and complete guidance to action, based on facts open and accessible to all. The existing morality, the Benthamites held, did not satisfy this requirement. It relied on religious doctrines which were not provable; it included traditional rules which had no ap-

parent, currently viable, justification; it contained a variety of conflicting and incommensurable demands, decisions between or among which were bound to be unpredictable and idiosyncratic. They offered a view which did not have these failings and which could therefore be considered as an improvement over the old code. Thus their appeal was to what might be called the form or function or nature of morality, and their claim was that that form might be more perfectly embodied in a content radically different from that which was currently accepted.

If we try to generalize from the case of Benthamism to obtain an account of a "revolutionary" mode of improving the moral beliefs of society we get something like the following. At a time of general questioning about and difficulty with an accepted morality, a new principle or set of principles may be formulated yielding clear and decisive guidance on outstanding and recurring moral problems. The new outlook includes much of what was held to be morally warranted or valid under the old, though it gives a different account of why it includes these points. Where it rejects segments of the old morality, it does so at least in part because it rejects certain extra-moral presuppositions of those segments. Insofar as the new view presupposes extra-moral beliefs, it involves only (or to a greater extent than the old view) those which are warranted by the most up-to-date methods of inquiry. It may involve revising the meaning of certain central terms in morality, and it gives a decidedly new direction to the overall pattern of action and assessment warranted by morality. If the new system gains the kind of general adherence of the moral community that the old possessed, if it has the power to attract new members of the community, and if it can continue to offer cogent and acceptable guidance through a fair period of time and over a fair range of problems, then it begins to function like an accepted morality, and we may say that a moral revolution has occurred. It should perhaps be added that the occurrence of a moral revolution is not a sufficient reason to claim that moral progress has occurred. There are revolutions in the name of reaction as well as in the name of progress, and the possibility of genuine prog-

ress logically involves the possibility of genuine degeneration. It is imaginable that the advantages a new system offers might be purchased at the price of abandoning certain substantive commitments which should not be given up for any gains in rationality, comprehensiveness, and smooth functioning. Our assessment of the degree of progress achieved by either a reform or a revolution must depend in part on our judgment as to how the new system relates to commitments of this kind; and as these commitments will be part of the old system, we must allow some force to the objection, discussed earlier, that any judgment of progress must be vacuous. That the matter is more complex than the objection realized is part of what the discussion of the possibility of moral revolution should bring out.

I have tried, then, to indicate two ways in which it may be possible to attempt to improve the content of our moral beliefs or commitments, and thereby to work for progress in the morality of our society. It has been suggested that the concept of "reformist" modes of achieving progress may be accepted by non-cognitivists as well as cognitivists. The same thing seems to be true as regards the concept of "revolutionary" modes. For the demands which a revolutionary theory is meant to satisfy, though not themselves simply moral demands, can as well be analyzed along non-cognitivist as along cognitivist lines. For this reason I have not given any consideration to the question of whether or not moral progress must be taken to be progress toward a final ultimate truth, or whether it should be understood in some other way. I should like to end, however, with what may be construed as a cognitivist's comment. There is a fairly clear, and by no means accidental, parallel between the two kinds of progress which I have suggested may be possible with respect to morality, and two kinds of progress which some recent commentators on the history of science claim to have discerned in scientific knowledge. Scientists are aware that revolutionary theories may be constructed which require extensive revision of present scientific beliefs and research programs. Moral philosophers and others who are, as it were, professionally concerned with

the morality of our times do not hesitate to call for piecemeal improvements, but no one seems to take very seriously the idea of what I have outlined as revolutionary change. I have no idea as to how effective an aid to the solution of the world's problems a revision, even a drastic one, of our moral beliefs would be, and I do not know whether such a change is called for by the difficulties with which our morality is faced. I only wish to suggest that if the concept of a moral revolution is a viable one, then the open-mindedness of moral philosophers toward such a possibility should at least equal the open-mindedness of scientists about the same sort of possibility.

Comments

JOEL FEINBERG

Not only *can* there be moral progress in Professor Schnee-wind's sense; I am convinced that there *has* been some, even in our own much maligned times. It was already the twentieth century, after all, when Kipling wrote his most popular poem about the "White Man's Burden," when German leaders in chorus claimed that the Germans were the strongest and best people in Europe and therefore deserved dominion over the whole continent, when American patriots spoke of their country's "manifest destiny" to rule the Pacific and impose Christian civilization on the benighted people of Asia. The very respectable Senator Albert Beveridge of Indiana won reelection and national acclaim at the dawn of our century when he proclaimed in deathless oratory: "We are a conquering race. . . . We must obey our blood and occupy new markets and if necessary new lands. . . . In the Almighty's infinite plan . . . debased civilizations and decaying races [are to disappear] before the higher civilization of the nobler and more virile types of man."[1] It was during the first decade of this century that the distinguished scholar who was president of Princeton University refused to permit Negroes to enter the campus except through a special gate for servants and delivery boys. (I assume that he relaxed that rule somewhat when he became President of the United States.)

Whatever be the character of our prevailing attitudes and national practice today, there can be no doubt that the rhetoric employed in justification of foreign adventures has been elevated, and that overt racism is out of fashion. Now we speak of "honoring commitments" to our "brave allies" and of "repelling aggression"; and no one who would be respectable will publicly shout "nigger" or boldly affirm racism—not even presidential candidate George

Wallace. There is, therefore, at least an improvement in the principles to which we pay lip service. Since there is no such obvious improvement in our actual attitudes and practices, it appears that a necessary concomitant to our "moral progress" has been a rise in *hypocrisy*.

Now, hypocrisy is a complex and fascinating subject that has not yet received its due from moral philosophers. Indeed, the word "hypocrisy" has not even received *its* due from the dictionary makers, who treat it as a rough synonym of "insincerity," a "pretending to be what one is not, or to feel what one does not feel."[2] Fraudulent pretense was surely the original sense of "hypocrisy" and is still a legitimate one; but the most interesting thing currently denoted by the word is a kind of unwitting self-deception. Some people properly called hypocrites are quite unaware of the gap between their professions and their conduct; they honestly mistake their conformity for piety, or sincerely believe that they love the neighbor whom they in fact despise. Whether fraudulent or self-deceptive, hypocrisy is surely not a good thing, and I don't wish to praise it here; but it may very well be one of those private vices that have public benefits—at worst it is a mixed social misfortune. George Orwell has made the case once and for all against hypocritical political sloganeering.[3] He showed how the language that expresses our ideals becomes debased in time and the ideals themselves forgotten. But the tension involved in all hypocrisy—the conflict between word and deed—exerts a pressure in both directions; and if there is a tendency for our language and our ideals to crack under the strain, the pressure is no less on our practice to move toward the ideals. And when a politician takes cover behind the rhetoric of his political adversaries, his move is a retreat in the struggle, and a temporary advantage at least for his enemies.

When Professor Schneewind speaks of "moral progress" he means an improvement in the morality of a group. He refers at various places to the morality of a generation (our parents), the morality of a social class (the middle class), the morality of nations (America), of traditions, and of institutions. The morality of any

of these groups, he implies, consists of the standards, norms, ideals, or principles that not only guide the conduct of its members but are also paid tribute to, "endorsed and defended," and employed in argument. I too have spoken of giving "lip service" to socially accepted principles. The question that now arises is: *whose* endorsement or lip service is required for a principle properly to be ascribed to a group as part of its "morality"? The very concept of a group morality, I think, implies a certain degree of consensus within the group. We can't very well speak of "the morality" of a group when we refer to moral principles over which it is split into fiercely contending factions. A group's morality then can be a mere lowest common denominator of conviction underlying a great diversity and conflict of opinion. There may be as many animal-haters as animal-lovers in the W.C.T.U., and as many drinkers as teetotalers in the A.S.P.C.A. Mr. Schneewind's nineteenth-century Evangelicals and Benthamites are still amongst us, importing their ancient quarrels into a dozen groups, sitting harmoniously side by side in a hundred others. The situation is complicated further by the fact that everybody is a member of numerous different groups, many of which can be said to have a morality of their own, and that most groups have some otherwise loyal members who reject the group morality that prevails. All of these factors make it especially difficult to characterize the morality of the most inclusive group of all, that of a whole nation.

If I may be allowed a bit of amateur sociology, I would like to suggest that a nation's morality can be reduced with only a small remainder to that of a subgroup of influential leaders. Ordinary men in their neighborhood pubs may be as inclined as ever to beat the daylights out of the wretched savages who cause us trouble abroad, and to cry "nigger" as freely as ever (almost); but that is no longer true of publishers, editors, politicians (even Wallace), judges, clergymen, college presidents, and the like. The morality of the group of leaders is not so much the sum of their several convictions as the sum of each man's belief about what all the others find acceptable.[4] To affirm imperialism or racism is simply not a

respectable thing to do any more among the people who matter, and it is the "people who matter" who call the tune. To ordinary men outside the establishment or the intelligentsia, these changes are no doubt as mysterious as changes in fashion and taste. Both moral and clothing styles are decreed each season in some secret place by those in authority (or so it may seem) and then filter down by the effect of example. Ordinary men may be lightly brushed by these changes, or they may remain indifferent to them; or they may resent them; but there is little they can do about them. Moral change almost always comes from above.

There are at least two different ways in which the influential people themselves are influenced to initiate change. They can be made to respond to pressure from mistreated groups struggling for social recognition of their rights. Acts of violence and intimidation are often effective, as are the various forms of political extortion considered legitimate in our society: economic competition, consumer organization, political lobbying, campaigning for votes, and so on. But secondly, there is also a role for moral "discovery": those who have more sensitivity, or empathy, or insight than most, might work for moral reform through persuasive writings and speeches directed mainly at persons of influence.

So far, I have considered only piecemeal changes. Now, what would a moral revolution look like? If a moral revolution is like other revolutions properly so-called, it will satisfy three different conditions; or, to put the matter more cautiously, to whatever extent a change satisfies these conditions, to that extent we would be inclined to call it a revolution. The change must be: (1) sudden, (2) drastic, and (3) fundamental. Since each of these conditions is subject to differences in degree, they can be treated as dimensions in which the revolutionary character of a change can be appraised and measured, so that a given change might be extremely revolutionary in one dimension, moderately revolutionary in another, and totally unrevolutionary in the third. The "suddenness" condition is obvious enough. A slow and gradual accumulation of small changes, barely noticeable as they occur, amounting after a century

or so to a complete transformation, is surely not a revolution. That the change must be a "drastic" one is almost equally obvious. A revolution is not simply a change from one thing to another. It is an overthrow of one thing by a very different or opposite one, not a mere addition or modification, but rather a radical inversion. Changes in public taste often have this topsy-turvy character. Ankle-length skirts are all the rage one season, mini-skirts the next. Moral standards too can be turned upside down, as witness the recent "sexual revolution" so-called. Sometimes these sea-changes are part of a general revolutionary overhaul of moral systems, but more often they are, as in the sexual case, changes that touch nothing fundamental in a group's morality taken as a whole. Until the sexual revolution is completed and a new order firmly established, I would be more inclined to treat it, in any case, as a recent inconclusive development in a continuing moral civil war that has been with us for several millenia, between those with ascetic and those with indulgent attitudes toward sexual pleasure. This ancient conflict has divided and distinguished whole cultures and epochs, and probably has its psychological roots in clashing styles of child rearing with their attendant forms of oedipal conflict.[5]

The third dimension in which change can be revolutionary calls for more comment, for it is the area where measurement of change is the most difficult, and also the dimension of change most interesting to students of moral and scientific revolutions. Wherever beliefs or attitudes are more than random collections, that is, whenever they are organized into a system with every concern given to internal consistency, a distinction can be drawn between the more and less basic or fundamental ones. The most basic tenets are the last ones to be tampered with when inconsistencies are discovered, for their logical position is so central that modifying them will send logical repercussions through the whole system. In a system of normative ethics as it might be presented, say, in a philosopher's book, there may be one supreme principle, or statement of "the right-making characteristic" at the top, from which are derived secondary

principles or maxims, from which, in conjunction with factual premises, are derived relatively singular moral judgments about such questions as birth control, capital punishment, and so on. When the system generates in this way a specific moral judgment that is in conflict with the system-builder's own spontaneous attitudes, he faces a kind of crisis. It is intolerable that his system be left with an inconsistency in it; but there are numerous options open to its builder. He can withdraw his own spontaneous judgment or reject his own general principle, or more likely, qualify the general principles in such a way as to accommodate the spontaneous judgment with the least possible amount of readjustment all told. Since our ultimate moral principles enjoy that status because they have in the past most faithfully represented the whole economy of our convictions, tampering with them should not be done lightly, and overthrowing them would come at an exorbitant cost to the many other elementary judgments they summarize and represent. Yet, there are times when the pressure of powerful new singular attitudes puts so much pressure on a fundamental principle that it finally breaks. Morton White has described this process aptly:

> The pattern of surrendering a moral principle is very similar to the surrender of an isolated physical principle when everything else is held constant. One exception after another eats away at the principle, and the same commitment to logical consistency forces its rejection as forces us to reject physical theories that go against observation. We come to forge our own positive ethical principles in a similar way; they are the principles which together with our other beliefs systematically organize our elementary moral convictions.[6]

The analogy here between ethics and science is compelling. Scientific beliefs also form a system in which we constantly seek, by the smallest possible modifications, to render singular and general statements internally consistent, and all established principles harmonious with new experience. The function of a scientific hypothesis, wrote William James, is to "marry old opinion to new fact so as ever to show a minimum of jolt, and a maximum of continuity."[7] Our scientific beliefs never form a finished system, and our new experience, no matter how much we know, always seems to

contain novelties and anomalies. The growth of scientific knowledge, for the most part, is smooth and continuous, but every now and then it kicks and jerks, and the jolt of the unanticipated reverberates through the whole system of accumulated beliefs. When the reverberations touch even those general principles that seem confirmed beyond question, then there is one of those infrequent crises in science's growth, as for example, that occasioned by Madame Curie's discovery of radioactivity or, as some claim, Dr. Rhine's discoveries in parapsychology. Sometimes we are so sure of our scientific principles that we feel obliged to distrust, discount, or otherwise explain away particular experiences that threaten to disconfirm them. "No amount of evidence," said Hume, "is sufficient to establish a miracle"; and it would take an enormous heap of ineluctable evidence to lead us to reject or even revise a law of the conservation of energy, or a law of gravity. Still, scientists are sometimes faced with such difficult options: should one change the principles "at the top" (or in Quine's metaphor, "in the center of the field")[8]—those from which so much can be deduced—or should one reject as inadequate the experimental evidence purporting to falsify the predictions derived from them? This is a conflict analogous to that in a moral system between settled principles and elementary moral convictions or attitudes. In both cases, reason would have us select the "hypothesis" that most economically performs James's "marriage function" between antecedently established principle and refractory new experience. When the evidential weight of the new experience is overwhelmingly coercive then it is established principle that must bend or break, and the more general and logically basic the principle thus affected, the more revolutionary the change.

The changes I discussed earlier in the prevailing attitudes toward racism and imperialism were not sudden enough to count as revolutionary in that respect, but they surely are revolutionary in that they are radical inversions or overthrowals. The more difficult question is: how fundamental or central in a wider system of beliefs were the overthrown tenets? Here I find difficulty in trans-

ferring a notion that makes perfectly good sense in one context to another where it is less at home. How much like a system of moral philosophy or a body of scientific theory, after all, is the "morality of a group"? Nobody consciously designs a group's morality or worries about keeping it consistent. Indeed, there is much less internal consistency in most conventional morality than in the criticial systems of Bentham, or Kant, or Epictetus. Consequently, it is too much to expect that a group's morality is subject even in principle to a rational reconstruction in which singular tenets are derived from general maxims which in turn are all tied together by a handful of ultimate principles. Mrs. Grundy is not that tidy.

Still, some of our conventional precepts are stated in more general terms than others, and thus apply to more cases and have broader entailments. There is flagrant inconsistency when a general principle exists side by side with a singular judgment that is the negation of the singular judgment the principle actually entails. Our national morality has no general principle, for example, that permits the strong as such to seize the property of the weak by sheer brute force here at home; and yet, if Senator Beveridge spoke for a national consensus, we acknowledged no moral restriction on the seizure of land from lesser breeds abroad. Our morality's general principle, in this instance, seemed to be at conflict with one of its own singular judgments; and the changes that moral reform has brought in our time resolved the conflict at the expense of the relatively singular judgment. The change in attitude toward imperialism, in short, has *not* been revolutionary; for it has not overturned one of the most basic general principles of the system. Rather it has cured the system of some inconsistency by rejecting a singular moral judgment and substituting for it, its own denial, as called for by a general principle. The change was in the direction of greater coherence; but it was not "fundamental."

Indeed, my imagination is at a loss when it tries to conceive of a *progressive* moral revolution in America today, and I wish Professor Schneewind, in addition to arguing that it is conceivable, had suggested what form it might conceivably take, while being

both fundamental and progressive. It is far easier for me to imagine a retrograde moral revolution than a progressive one. It might be useful to recall at this point the world's most recent attempt at a moral revolution. The so-called "new German values" deliberately promulgated by the Nazis (and with a good deal of success) were radical inversions of some of the most central principles of the morality of Western civilization. They took hold in the German morality as a result of pressures put on a remarkably compliant social establishment, pressures ranging from terror to social suasion and bribery. And once the socially respectable classes switched, the rest was easy. What the Nazis were doing, if we can believe Hannah Arendt, was in effect creating a new German conscience. Those with weak convictions but a great craving for respectability were easily stripped of their old moral beliefs, and new "convictions" followed quickly from the perception of what the "in people" approved. In Adolf Eichman's case the changeover from the old conscience to the new prefabricated one took about four weeks. His first conscientious doubts

> had been put to rest when he saw the eagerness and zeal with which "good society" everywhere reacted . . . not just the S.S. and the Party, but the elite of good old civil service. . . . "At that moment [said Eichmann] I sensed a kind of Pontius Pilate feeling, for I felt free of all guilt." *Who was he to judge?* Who was he, as he expressed it, "to have my own feelings in the matter?"[9]

Eichmann's civilized conscience troubled him for a brief period after the brutal shippings and killings began. But then the "new German values" took over, and fortified by a new sense of duty, he overcame his natural repugnance and threw himself into his work. Sympathy for fellow creatures was now turned around and directed at the self suffering in its faithful obedience to duty: ". . . instead of saying 'What horrible things I did to people!,' the murderers would be able to say 'What horrible things I had to watch in the pursuance of my duties! How heavily the task weighed upon my shoulders!' "[10] In such inglorious ways are some moral revolutions made. And yet I have no doubt that had the Germans won the war, the doctrine of the ultimate moral equality

of men, central to our moral tradition, would, in their territory, be as dead as the right of private vengeance and the Divine Right of kings.

One final point. I am somewhat puzzled by Professor Schneewind's repeated references to the controversy between "cognitivism" and "non-cognitivism." By my count, he refers to these theories five different times in his paper, only to dismiss them as logically irrelevant to the solution of his problem on four occasions, but finally permitting himself what he calls a "cognitivist's comment" on the fifth occasion. Now, part of what it is to be a cognitivist, I gather, is to be impressed by analogies between science and morality. I am as impressed as Professor Schneewind by one of these analogies. Both science and morality lend themselves to formulation and development as systems of beliefs related in established orders of logical priority, subject to a characteristic dialectical interplay between the relatively general and privileged statements at the center and the relatively singular and corrigible statements at the periphery. Both moral and scientific statements are open to new experience and perpetually subject to revision in the light of new experience. In both cases, conflict between established principles and refractory new data are to be decided in favor of the established principles at first, but when counter-instances accumulate and chip away at established principles, the latter are overthrown. When this happens, the system builders must replace the old principle with a new one that can perform James's "marriage function" by doing the explanatory work of the old principle while still doing justice to the new experiences.

But having made that concession, I must confess to some non-cognitivist inclinations too. If there are important analogies between science and ethics, there are some important dis-analogies too. Before getting to one of these, let me point out that "cognitivism" and "non-cognitivism" are theories about the nature not of conventional morality—the "morality of groups"—but rather of critical morality. They are theories about the meaning and mode of confirmation of the judgments by which men express their con-

victions about what is *really* right and wrong, conventional morality notwithstanding. If cognitivism is the view that critical morality is essentially or primarily a matter of the head, and non-cognitivism the view that critical morality is essentially or primarily a matter of the heart, then the theories are only contraries, not contradictories; for one could hold, as I do, that critical morality is essentially a matter of both the head and the heart.

Mr. Schneewind speaks of making "moral discoveries" analogous with the discoveries made in scientific laboratories. But in what dark corner of the world should we look to discover new moral truths? Here I am not so impressed by analogies with science, though between any two kinds of things, of course, there will be some analogies. Moral discoveries, it seems to me, are products of expanded sympathies, keener insights, and refined sensibilities, as well as of the more familiar cognitive skills at seeing similarities among differences and differences among similarities and predicting remote causal outcomes. An essential prerequisite for the moral seeker is that his heart be in the right place, that he care about the right things, that things matter to him in proportion to their real importance. But if a person cares too much, say, about human suffering, he might fall into a self-defeating sentimentality; and if he cares not enough, he may become unscrupulous in the pursuit of otherwise commendable goals. Therefore, he must care in just the right way, and to just the right degree. Learning how to care in this way, it seems to me, is at least as much like learning how to write poetry or to play the piano as it is like designing a laboratory experiment or taking meter readings. Appropriate concern of just the right sort is as essential to moral insight as is reasoning ability or observation. If that be non-cognitivism, let us make the most of it.

In summary, I agree with Professor Schneewind that groups have moralities, that these moralities change, and that the changes are at least sometimes improvements. So there can be moral progress, and indeed, there has often been moral progress in the past. Some moral progress has been revolutionary, though by its very nature revolutionary change is the exception rather than the rule. (Perhaps the

overthrow of the once universal practice of private vengeance was revolutionary. Another example might be the triumph of the doctrine of the rights of man in the eighteenth century.) Since I grant all of this, I must also accept Mr. Schneewind's final admonition to be open-minded toward the possibility of a moral revolution in our own time and place. All right, I'll be open-minded; but I can't help but be puzzled about the point of the admonition, especially given the analysis of moral revolution I've sketched here. Suppose this were a gathering of philosophers of science, most of whom were also scientific practitioners—theoretical physicists, experimental psychologists, and the like—and the speaker, himself a highly esteemed scientist and philosopher, urged as his main point that they remain open-minded about the possibility of future scientific revolutions. I would think that the audience would wonder what well-received central scientific principle had become subject to doubt in the speaker's mind. "What is he preparing us for?" they would wonder. "Is he impressed by the evidence for extrasensory perception or psychokinesis? Is he urging us to take these specific revolutionary possibilities more seriously?" I feel somewhat the same way about Mr. Schneewind's lecture. If we can reconstruct our morality so that it is a system, which of its general principles are central to it in the way the law of the conservation of energy has been in physics? And what reasons does Mr. Schneewind have up his sleeve for wondering whether one of these principles is ripe for revolution? Until I know that, I am willing to be open-minded toward the possibility of moral revolution in something like the way Hume was "open-minded" toward the possibility of miracles, and most theoretical physicists toward the possibility of spiritual action at a distance. But that's not *very* open-minded.

NOTES

1. Quoted by Barbara Tuchman, *The Proud Tower* (New York, 1966), p. 153.

2. *Webster's New World Dictionary of the American Language* (Cleveland and New York, 1966).

3. "Politics and the English Language," included in *A Collection of Essays* by George Orwell (Garden City, 1954), pp. 162-77.

4. This line in my orally presented remarks is obviously a piece of rhetorical hyperbole. The morality of a group consists partly of widely shared convictions about what is right and wrong, and partly of even more widely shared expectations of its members about what sorts of conduct and expression will be well or poorly received, and their individual perceptions of what Mrs. Grundy finds respectable or shocking, quite apart from, or in addition to, their own convictions. This analysis suggests that there is usually a "conviction lag" in a group's morality, the result of large numbers of persons being prepared to contribute social pressure against nonconformists in the absence of any genuine moral conviction that their nonconformity is wrong. The conviction lag I would expect to be less in the more influential subgroups, but I have no doubt that it exists even there.

5. See G. Rattray Taylor, *Sex in History* (New York, 1954).

6. Morton White, *Toward Reunion in Philosophy* (Cambridge, Mass., 1956), p. 257.

7. William James, "What Pragmatism Means," *Pragmatism: A New Name for Some Old Ways of Thinking* (New York, 1907), p. 61.

8. W. V. Quine, "Two Dogmas of Empiricism," *From a Logical Point of View* (Cambridge, Mass., 1953), p. 42 et passim.

9. Hannah Arendt, *Eichmann in Jerusalem* (New York, 1963), p. 114.

10. Ibid., p. 106.

Democracy and Disorder

ARNOLD S. KAUFMAN

The tactic of disorder in pursuing political goals is often thought to be morally wrong for members of democracies like Britain and the United States. For those who live in such democracies there are supposed to be reasons against resorting to disorder that do not hold for members of non-democracies. In this view Americans who are plagued by racial discrimination have reasons for rejecting the tactic of disorder as a way of resisting their oppressors that Czechs plagued by tyrannical political masters do not have. I will argue that the presumed distinction between the obligations of citizens in democracies and non-democracies lacks a significant moral basis.

I

Before developing arguments for my main thesis, certain matters require clarification.

First, for purposes of this discussion, acts of disorder will be understood as violations of law that involve intentionally inflicting physical harm on persons or property. Disorder differs from civil disobedience in that, though both involve illegal action, the former implies an intentional harm which the latter precludes.

Second, democratic political systems are like those that exist in the United States and Great Britain in the following crucial respects. Organized opposition is legally free to form and contest for governmental power through an electoral process. The franchise is widely held, and is, in particular, not limited by political test. There is reasonably little direct governmental interference with speech, press, and inquiry. Finally, the legal system does not normally

operate capriciously. That is, given knowledge of statute and precedent, judicial decisions are reasonably easy to predict.

Because this working definition of "democracy" is neither precise nor the one best suited to development of a morally adequate political theory, a further word of explanation is required. The definition does correspond to the conception commonly held by people in democracies like Great Britain and the United States. Countries that those citizens normally regard as democracies are, by this definition, democracies, for example, France, India, Japan, and Uruguay. Countries they typically think of as non-democratic are non-democratic, for example, Russia, Spain, Yugoslavia, and Paraguay. Arguable cases turn out to be borderline; for example, Mexico and South Vietnam.

The position I am arguing against is held by people who generally understand "democracy" in roughly the way specified. False issues are avoided if their meaning is, in this respect, accepted as basis for discussion.

Third, I am concerned only about acts of disorder that aim at some political objective. Someone may be morally justified in assaulting a friend who has betrayed a trust, but few would argue that the nature of their political system is relevant one way or another. It is in the sphere of political action that democracy is supposed to have some special significance as a reason for refusing disorder.

Fourth, though I will have much to say about bad arguments against disorder, I am not defending the use of disorder; only arguing that democracy gives us no special reason to reject its use as a political tactic. Considerations weigh against practicing disorder in any political system. Inflicting harm on persons or property is intrinsically bad. Hence the burden of proving that disorder is, in balance, a desirable tactic always falls on the one who intends its use. Similarly, someone who acknowledges a commitment to democracy is under an obligation to reject disorder as a means of pursuing his political goals because his commitment implies an obligation of obedience to the outcomes of the democratic process. But it is the *commitment* that generates the obligation, not the fact that

it is a commitment to *democracy*. Someone committed to an auto-cratic system would have the same moral obligation to abide by the results of the autocratic process. Of special interest is the following argument. It is often claimed that if we grant to anyone in a democracy the moral right to prac-tice disorder, we must, on pain of inconsistency, permit everyone to do so; not only those who fight racial discrimination, but those who defend it; not only those who oppose unjust wars, but those who support them. Now it does not matter, for my purposes, whether one argues for this position because he believes in moral relativism or because he thinks some principle of universalization has application. As far as the central thesis of this essay is concerned, the main point to be made is this: such arguments, whatever their force, hold for *any* society. They do not provide a basis for differ-entiating the obligations of citizens in democracies and non-democracies. In fact, I think that all such arguments are unsound. But that is matter for a different essay.

II

There are roughly three sorts of special reasons why democracy is often thought to imply a strong obligation to refrain from dis-order: first, intrinsic virtues the process is presumed to have just because it is the sort of process it is; second, the power of the demo-cratic process to produce right decisions; and third, the relative harm that results from resorting to disorder when, in democracies, a peaceful electoral route to desirable change invariably exists. I will consider each of these lines of argument in turn. My aim is to exam-ine all plausible arguments that favor the thesis I aim to refute.

A. Consent

It is often claimed that laws bind only when one has given con-sent. Membership in a democracy, so the argument runs, always implies consent. The same does not hold for any other political system. Hence, members of democratic societies are obligated to obey the law. The obligation is weighty in proportion as the viola-

tion of law is grave. Involving, as it does, harm to persons or property, disorder is always a very serious violation of law. Therefore, in democracies there is always comparatively strong, usually decisive reason for rejecting disorder.

The doubtful link in this chain of reasoning is the view that membership in a democracy *always* implies consent. One straightforward defense of the claim is that after reasonably careful deliberation everyone in a democracy pledges to abide by the rules and directives produced by the system. Such a picture of what members of democracies do is, of course, fatuous. Most people neither deliberate carefully, nor make explicit pledges of the sort required. Rather they are mostly born into democratic societies and come to accept the rules as authoritative without very much thought. The same is generally true within non-democracies. One would not be likely to discover a significant difference between India and Russia in this respect.

Moreover, even when careful thought leading to explicit pledges does occur, it is questionable whether the choices made are "reasoned" in the morally relevant sense. For, as many critics of advanced industrial societies have recently argued, forms of reason are often satisfied when its substance is violated. Manipulation, inculcation, threats, and more subtle consensual pressures often determine, in pervasive ways, what passes for "rationality." The very criteria of what counts as a good reason may be "coercively" shaped by mechanisms that are destructive of a life of genuine reason. No one who has ever seriously been engaged in conflict with established political authorities can doubt it.

However, too much stress is being placed on the idea of explicit commitment. Those who believe that membership in a democratic society implies consent usually have tacit, not explicit, commitments in mind. The underlying rationale is best put in the following way.

In democracies everyone has the opportunity to participate in making basic policy decisions. If someone refuses to exercise his option, if he refuses to participate, he is yet free to leave the society. This freedom to choose exile plus an opportunity to participate are

enough, it is thought, to support an implicit commitment to democratic process and a corresponding obligation to refuse disorder.

But this argument is no better than the previous one.

First, nothing resembling a genuine promise need occur. In democracies it is generally true both that people are legally free to participate in a certain range of important political decisions, and that they are legally free to leave the country. Still if someone, for whatever reason, is unable or unwilling to exercise either option, then to use the fact that he is legally free to do so reduces promise and corresponding obligation to the vanishing point.

Whether explicit or implicit, voluntary commitments are individual matters. Even if most people in democracies do accept the rules of the system, many do not. Indeed, those most inclined to practice disorder as a political tactic are precisely the ones also most inclined to repudiate the democratic system. So the point has more than abstract importance.

Such a person may decide to remain in the country for all sorts of reasons unconnected with its being a democracy. He may believe that it is a better society than any other despite its being a democracy. Or he may decide to stay because this is where his home and family are; these are the hills, mountains, and plains that restore him; this is the language and culture that most satisfy him. A man may hate Soviet Communism or American democracy, yet love Mother Russia or America the Beautiful. Or he may refuse to go because he can't afford to leave; or, because, despite his belief that the political system is loathsome, he thinks that this is where his fight for a better world can best be made. Given any of the foregoing conditions, someone who explicitly repudiates democracy cannot be said to have made a tacit promise to obey the laws merely because he does not exercise a legal option to leave. Obligation to refuse disorder that is set on this foundation is set in quicksand.

Moreover, a merely legal opportunity to participate may be a far cry from full-fledged opportunity to become significantly involved in the decision-making process. Black residents of Alabama, Indians in Montana, or Mexican-Americans in Texas may be as ef-

fectively barred from genuine political participation as they would had they been legally disqualified from voting. And when millions of young Americans who lack even a legal opportunity to exercise the franchise are nevertheless told that they must obey the laws of the selective service system because "political opposition to a particular war should be expressed through recognized democratic processes and should claim no special right of exemption from democratic decisions,"[1] the full absurdity of insisting that every member of a democratic society has implicitly pledged to abide by the rules of the system is made plain. Surely someone who is said to have an obligation to jeopardize his life for his country deserves better reasons than that he will one day be able to vote and if he doesn't like it here he can go elsewhere.

B. The Justice of Democracy

One might argue that democracy is a just system for making political decisions, and that, therefore, everyone has a special obligation to abide by the results of the process. Putting to the side the question of why the justice of a process would, even in the absence of belief that it is just, obligate one to reject disorder, it may reasonably be doubted that democracies, as defined, are necessarily just.

Presumably the United States was a democracy in the specified sense when Thomas Jefferson explained why he thought slaves and women ought to be barred from voting.

> Were our state a pure democracy in which all its inhabitants should meet together to transact all their business, there would yet be excluded from their deliberations . . . women, who to prevent depravation of morals and ambiguity of issue, could not mix promiscuously in the public meetings of men; . . . slaves, from whom the unfortunate state of things with us takes away the rights of will and property.[2]

Apparently even the most democratic of the Founding Fathers did not favor anything most present-day Americans would recognize as a just system. And there is much reason to believe that the present state of American democracy is not as far removed from its original

injustice as many apologists would like us to believe. Other democratic societies are, on the whole, even less just than American society. The point is, even if the argument is sound there is little reason to think that it has much application to existing democracies, such as they are.

Of course one might shift the terms of the argument by conceding the defectiveness of existing democracies, but arguing that a perfected democracy would be just. It is for perfect democracies that the argument holds. But the idea of a "perfect democracy" is obscure. If it is supposed that a perfect democracy is necessarily just, then how do we know that it can exist? The presupposition that it can be achieved begs a very important issue: can a system that is enough like imperfect democracies to be called "democratic" be purged of all injustice? Or is some alternative decision-making process just? To make the point of these skeptical questions clear, one need only consider a defense of autocracy based on the claim that, though all existing autocracies are imperfect, a perfect autocracy would necessarily be just. A convinced democrat should immediately ask whether autocratic systems *can* be perfected.

Even assuming that some form of democracy is sometimes just, there is little reason to believe that democracy is the only form of government that can be just under all sets of social conditions. Many argue that democracy, in any plausible form, would be bad for certain underdeveloped societies in which unfavorable cultural conditions prevail. Only an ideology impervious to the plain facts of the modern world can continue to hold unquestioningly to the view that democracy ought to be implanted in every land; that no variation in institutional conditions can justify a non-democratic political system.

C. Gratitude and Obligation

Some argue that as democracies invariably produce benefits for their members at a much higher level than any alternative system, each inhabitant owes a debt of gratitude to his respective democracy.

In the previous section I rejected the idea that, for any given society, democracy is certain to be more just than any alternative political system. The supposition that democracy invariably produces benefits at a higher level than does any alternative system deserves to be treated with similar skepticism. But for purposes of argument let us waive such doubts. Suppose it is true that democracy does produce benefits for its members at levels higher than any non-democratic alternative. Suppose also that what counts as a benefit is specified in some plausible way—any way that is reasonably thought to be plausible will do. From these assumptions it would not follow that the level of benefits is higher for every person in a given democracy than it would be if the democratic forms were supplanted by some non-democratic alternative. For example, an Ulster Catholic may justifiably think he is worse off there than he would be if a Catholic autocracy were established in Northern Ireland. If, in pursuit of this political objective, he practices violence against Ulster's democratically elected Protestant rulers, it would be wrong to criticize him on grounds that he owed a debt of gratitude to Ulster, or Great Britain, because its democracy benefited him.

The point to be stressed once again is that *individuals* have relevant obligations. Even if the aggregate benefits within democracies are higher than in any non-democratic alternative, these benefits may be so badly distributed that no debt of gratitude is owed by a particular individual. If this is so, he at least does not have the reason given for refusing to use disorder to achieve political goals.

But there is a second and more interesting objection to the line of reasoning that moves from benefit to gratitude to obligation. That obligations are ever appropriately generated by gratitude may reasonably be doubted. And the considerations that warrant skepticism about the connection between gratitude and obligation also make dubious the idea that gratitude ought ever to be felt towards states; or, for that matter, any other corporate agencies.

In the *Crito* Socrates likens Athens to a nurturing parent. Partially on this basis he argues that he is obligated to obey Athens'

laws, and therefore to sip the hemlock. And this obligation holds even though, as he acknowledges, his death has been unjustly decreed. Though Socrates does not explicitly say that the obligation he owes Athens is a debt of gratitude for nourishment received, it seems reasonable to suppose that this is the explanation he would have given had the assumed connection between nurture and political obligation been questioned.

But whatever debts are owed parents are not owed out of gratitude. To suppose that they are is to misconceive the role gratitude, and similar moral sentiments, should play in the moral life.

In a rough way we can distinguish between two spheres of moral concern. One is, so to speak, bounded by close personal relations. This is the sphere in which we engage others in particularly intimate ways. It includes friends, lovers, children, parents, and so on. The other sphere is bounded by those with whom our relations are impersonal. Within it we are preoccupied with the fate of "the blacks," or "the poor," or "the law-abiding," or "the mentally retarded." Or we have a political interest in the problems of a convicted murderer who awaits capital punishment or an embattled college president who awaits student disruption. It is, in brief, the sphere in which we are concerned with people, not so much as identifiable, known individuals, but primarily as unknown objects of policy. No doubt these two spheres overlap and intertwine. But for purposes of the moral life, it is essential that an analytic distinction be made between them.

Ideally, within the sphere of intimacy we do things out of love, affection, friendship, perhaps gratitude. These primary moral sentiments are the basis of motives to do things for others. To the extent that their force is mediated by a sense of duty, relationships lose their intimacy. The distinction blurs between those with whom we are daily engaged in countless ways, and those for whom our concern, however genuine, is abstract because the objects of concern are remote. It is not that we cannot acknowledge obligations to those we love, or to those towards whom we feel gratitude; it is just that to the extent that duty calls, love or gratitude are not func-

tioning in a way that supports healthy primary relationships. We have good evidence that something has gone seriously wrong in those relationships.

Of course parents and children in almost any existing society do have reciprocal rights and obligations. But that is because a political judgment, either explicit or implicit, has somewhere been made to achieve the discharge of certain essential social functions through the family structure. The range of those functions is subject to constant change. Once parents had almost exclusive jurisdiction over the education of their children. Today their duties in this respect are sharply curtailed. A state regulated system of compulsory early education has supplanted what many parents regarded as their their right, and what was certainly the child's right and the parent's obligation. Many still regret this development. And it is a nice question whether, by increasingly expanding the bounds of the welfare state, thereby converting family duties into governmental obligations, society does not free families of moral constraints that contaminate primary relationships.

The converse of my thesis is that considerations of general utility, but also claims of right and duty, are mainly what define relationships within the sphere of impersonal relationships. To the extent that debts of gratitude are inappropriate, gratitude has no role to play in relationships between those who are remote in time and place—and certainly no role to play between individuals and abstract corporate entities like states. When gratitude, rather than reciprocal acknowledgment of rights and duties, governs the relationship between the state's officers and ordinary citizens we can be reasonably sure that cronyism, not justice, determines how those citizens are being treated by officials.

The distinctions mentioned, but not developed here, the general points stated, but not elaborated, have profound theoretical importance. To put matters oversimply, Christians and Marxists have sometimes erred in supposing that love, in its primary form, should hold between any two randomly selected human beings. Conversely, utilitarians and natural rights theorists have often been wrong in

supposing that all relationships between individuals are governed principally by questions of utility, rights, and obligations. But my purpose is not to defend these claims in the detail required. Rather I have tried to bring them to focus for the sake of making one important point—that gratitude is not an appropriate basis for deriving an obligation to obey the laws of a state. Socrates would have done better to drop the analogy between state and nurturing parent in defending his determination to slip the mortal coil.

D. Peaceful Change

One argument turns, not on democracies' overall benefits as compared to non-democracies, but on a specific advantage the former are supposed to have over the latter. It is supposed that in a democracy, peaceful redress of legitimate grievance is always possible, and that a peaceful route is always better than any alternative path that involves disorder. (And here by "peaceful route" all that is meant is "route involving no disorder.") If these claims are true, the argument yields not merely a special reason to reject disorder in a democracy, but a decisive one.

Let us assume at the outset that democracy does guarantee the existence of a peaceful route to any desirable goal. Suppose that one such particular goal, for example racial justice, can be achieved by either a peaceful or a disorderly strategy. In determining which of the two paths is better, all relevant goods and evils should be taken into account—intrinsic and consequential, justice and utility. That is, the moral point of view adopted for purposes of policy judgment is not necessarily utilitarian. Let us suppose also that the relevant goods and evils can be weighed in some balance, a determinate judgment rendered between the alternatives. Is it plausible to suppose that, within democracies, the peaceful path to racial justice is invariably preferable to the disorderly alternative?

One line of reasoning that makes the conclusion seem plausible takes as its point of departure awareness that, in most contexts calling for political judgment, much ignorance of relevant conditions and consequences exists. Hence, it is argued, there are never deci-

sive grounds for excluding the peaceful path. It is always possible that a peaceful path can be found which is less harmful than disorderly alternatives. Peaceful paths to desirable change do, however, tend to produce less harm than disorderly alternatives, for harm is essential to the latter and not to the former. Therefore, within democracies, a peaceful path to racial justice is always better than any disorderly alternative.

But this argument contains two quite common fallacies of political argument.

The first might be called *the fallacy of improbable possibilities*. The general form of the fallacy is to accept judgments based on beliefs about possibilities when only estimates of probabilities will make the argument sound.

In this instance, it is not the *possibility* that a peaceful path will involve less harm than any disorderly alternative that must be established, but the *probability* that this is so. For if, in a particular situation, it is possible that a peaceful strategy is less harmful than a strategy of disorder, but evidence warrants the claim that disorder is *more likely* to involve less harm than a peaceful alternative, then the disorderly route is the one that ought to be traveled. Suppose racial injustice can be eliminated either through electoral effort alone, or through electoral effort in combination with organized violence. Then if the first, entirely peaceful, route *might* involve less harm than the second, disorderly alternative, but the second *probably* involves less harm than the first, from a moral point of view we ought to favor the disorderly alternative. Remember, the harm is judged to be less after *all* relevant values are taken into account, including violations of principles of justice that might be involved in practicing disorder.

The point is that the mere possibility that a peaceful path to desirable change will involve less harm than a partly disorderly alternative is not enough to establish the moral superiority of the former.

The second flaw in the argument might be called the *fallacy of illegitimate tendencies*. One way of giving a bad policy judgment a semblance of validity is by referring to very general *tendencies*. That peaceful tactics generally tend to produce less harm than dis-

orderly ones may be true. That this tendency is greater in democracies than in non-democracies may also be true. But neither admission implies that peaceful paths *are actually* always better than disorderly ones—even within democracies. Not the general tendencies of abstract possibilities, but likely harm or benefit produced by concrete alternatives must be taken into account when specific policy judgments are made. In making political judgments there is no way in which strenuous thought about messy particulars can be safely avoided. To rely on very general tendencies is one way that is least safe.

However, there is one variant of the argument just criticized that is both valid and sound. More than any alternative political system, democracy does increase the likelihood that social advance can be brought about peacefully. Therefore, *in the absence of much knowledge of messy particulars,* within democracies we do have a special reason to suppose that a peaceful route to desirable change that is preferable to any disorderly alternative can always be discovered. However, the special reason that exists is so weak as to be of little practical importance. All it suggests is that, in any particular case, we ought to explore the possibility of finding some peaceful route to change before adopting a path of disorder. It does not guarantee that we will find an alternative that is preferable to a disorderly tactic; nor even that we will discover a possible alternative. Nor does it give us much reason, besides the fact that disorder intrinsically involves harm, to explore peaceful tactics. Thus the argument does nothing but place a slightly heavier burden of proof on those who consider disorderly political tactics when they are members of democratic rather than non-democratic societies. But the extra burden will weigh very lightly on anyone who acknowledges the existence of injustice, and quite properly so. And it will weigh not at all on someone who knows enough about the particulars of the situation in which judgment is required to discount its relevance.

Yet the original argument can be stated in a form which is free of fallacy. Within democracies, it may be assumed, pursuit of desirable change is, in every particular situation, more likely to involve

less harm if a peaceful path rather than a disorderly path is taken. But as everyone has an obligation to pursue desirable changes in ways that produce least harm, everyone in any situation has an obligation to act without disorder.

Continuing to assume that a practicable peaceful path always does exist, the assumption that it will invariably, in every concrete situation, involve less harm than some disorderly alternative is, to put it gently, not likely to be true. But, more significantly, there is much reason to doubt what has been granted up till now—that a practicable peaceful path to desirable change always does exist in democracies. Certainly the histories of democracies yield little basis for such optimism. In the United States, for example, it is doubtful that practicable peaceful alternatives to tactics involving much disorder could have ended slavery, widened the effective franchise, organized trade unions. In any society where vast inequalities of power, status, and wealth exist, there is little likelihood that a peaceful path can always be discovered, or that when discovered it will always be preferable to tactics involving disorder.

Indeed, the very persistence of striking inequality indicates that the democratic process has not provided a tolerably efficient means of achieving urgently needed redress of legitimate grievances. In the United States recently, every published report issued by task forces set up under the presidential authorization to study violence carries the same basic message: disorder is a predictable reaction to institutional rigidities of the democratic political system. Even Abraham Lincoln, in his debates with Stephen Douglas, seemed honestly to suppose that slavery would wither away over time, partly through the steady application of democratic remedies. But Douglas had the weight of reason on his side when he insisted that without civil war slavery could not be abolished. On the other hand, Douglas was wrong in assuming that such strife was not a moral price worth paying to end slavery; or so someone can plausibly argue.

While it would not be appropriate here to explore the empirical basis for believing that democracy is a less efficient engine of peaceful social progress than is generally thought, before leaving this topic I do want to explore one reason why so many are inclined to

think that peaceful paths to desirable social change always involve less harm than disorderly alternatives. It is an argument that provides insight into the general disposition to accept bad arguments for the claim that all members of democratic societies have a strong obligation to reject disorder.

There is a tendency to ignore the fact that peaceful paths to social progress may be grindingly slow; that disorder will bring the desirable change about much more rapidly. Obviously, if a peaceful strategy takes one hundred years longer than a disorderly alternative, we must question whether the harm done by permitting social evils to fester for a century longer than is necessary outweighs the extra harm involved in the choice of disorder.

And there is good prudential reason why the harm that occurs by permitting chronic social evils to persist for long periods of time is implicitly discounted by many people, especially those who are relatively well off in terms of power, wealth, or status. Those who are relatively advantaged, whose basic position in society is comfortable and secure, are all too often very patient about wrongs that only afflict others. They do not normally suffer the consequences of delaying remedy. They are especially patient about injustice if, as is usual, righting existing wrongs requires that they yield some of their social perquisites. There is good conservative sense in Pareto's idea that social policy is justified only if at least some enjoy gains and no one suffers loss.

Naturally, if those generally elected to powerful offices in democracies are largely drawn from this group of relatively privileged individuals, the problem of resolute indifference to the suffering of underdogs will be intensified. Moreover, even if a leader emerges from among the oppressed, his patience with existing injustice is likely to grow as the perquisites that his office gives are enlarged. That is to say, there is a social dynamic that makes for what many regard as a fundamental tendency of liberal democracies—cooptation.

Finally, in the more affluent democracies, many develop an exaggerated fear of the possibility that steady pressure for desirable radical change will promote right-wing reaction, even fascism. His-

torically it is true that when societies are forced to choose between order and anarchy, they have tended to choose order however much repressive force has been required to restore stability. In response, those who sought change have been pushed increasingly towards violent revolution as the only effective way to eliminate injustice. However, these historical tendencies have typically occurred, and where they persist still occur, within societies that suffer extreme material scarcity. Resistance to change is quite understandable if one perceives the granting of meaningful reform as certain to result in self-pauperization. That is undoubtedly at least in part why a favorite conservative argument against redistribution of wealth is that it benefits each individual in the mass very little while leveling the aristocratic few. Opposition is then further justified on grounds that this leveling process destroys literature, science, all the cultural amenities of a great civilization.

But as some societies industrialized and became more affluent, an alternative to repression began to emerge. Instead of putting the discontented down with force, buying them off by minimally meeting demands gained favor. Great Britain had a lead time of about fifty years over the other highly industrialized societies. It is not surprising that it was there that the political art of buying discontent off was first brought to a high pitch of development. In particular, one device for facilitating the process of buying off discontent was loosening the reigns of political autocracy; moving in the direction of political democracy. This was especially safe where, as in Britain, the institutions of social despotism remained strong, or where an effective electoral majority of those who were privileged could be constituted. Thus, throughout Britain, scarce access to the best education was a powerful device for maintaining structures of unjust inequality. And in Ulster the democratic hegemony of Protestants has only recently been challenged on the barricades by Catholics. In any event, in a carefully paced, socially controlled way, the franchise within affluent democracies has been gradually extended to underdog minorities. Thus has political de-

mocracy been perfected in parallel with the art of buying off discontent.

Marx's prediction that the proletariat in each society would be progressively immiserized has failed principally, I think, because he miscalculated the growing willingness of the advantaged to trade a portion of their advantages for social stability. The democratic process has provided a mechanism for effecting this trade-off with least cost to those who had most. For, generally speaking, political democracy has operated in accordance with the principle of diminishing marginal utility. That is, those most oppressed were generally benefited least by democratically won reforms. This phenomenon is characteristic of almost all advanced industrial democracies, and may be described as *the principle of tokenism*. It must be remembered, however, that by concatenating token gains, significant, even radical changes can, over time, be won.

And this brings us back to the problem of balancing the costs involved in peaceful, but slow, against rapid, but disorderly, redress of legitimate grievance. What tends to happen as democracies become more affluent is that discontent at the moral costs of tokenism grows. That is, the marginal costs of securing social stability rise as expectations thought to be morally legitimate grow. And expectations themselves grow as token gains are more rapidly won. Thus, within political democracies, the very success with which democracy functions tends to inflate the rhetoric of political discontent, tends to enlarge the extent of the criticism of the democratic system itself. A tension develops inside the class of those who are better off. On the one hand they resent what they perceive as unjustifiable escalation of political demands, rising levels of social disorder. This inclines them in the direction of repressive measures. On the other hand, as the increasing level of expectations that produces both demand and disorder is itself a byproduct of the perceived ability of those who are advantaged to yield a portion of what they have without suffering impoverishment, there is also a disposition to trade off more of what one has for social stability. The society is,

as it were, seen as balanced on an edge that separates dangerous anarchy and repression from hopeful willingness to pay the price necessary to buy stability.

The point at which this analysis has been driving is that too many emphasize the danger without acknowledging the basis for hope. And many factors—perhaps less dramatically evident than the brutal exercise of police power, or mockery of judicial procedure, or inquisitorial legislative investigation—exist to show why a very affluent democratic society should induce greater payoffs even while the forces of repression grow. Social instability hurts business, jeopardizes personal security, damages the political prospects of office-holders, and so on.[3]

Nothing I am claiming here implies that repression cannot grow, or that democratically won payoffs are bound to grow. But I do think that the overall tendency of the system to respond by facilitating the latter and dampening the former is seriously underestimated by those who think that disorder is invariably counterproductive. Indeed, disorder may often be the catalyst that causes the democratic process to function more efficiently than ever before to eliminate chronic social ills.

Another tendency that develops parallel with the growing, but exaggerated fear of right-wing repression is the effort to dampen the disorderly pressures within society by characterizing them as "immoderate," "irresponsible," "unreasonable," or even "irrational." That is, to a very considerable extent our work-a-day notions of what it is to be reasonable and rational in political affairs are shaped by the implicit tendency of those who are better off to mute the clamor of those who are moved to consider disorder as a political tactic. This subtle and by no means deliberate process by which the very language of rationality is shaped to suit the ideological needs of more conservative social forces is, of course, especially infuriating to those who believe that they have both morality and reason on their side in the struggle to build a good society.

The foregoing analysis of tokenism within democratic societies underlines a claim made previously. The idea that a peaceful route

to desirable change can always be charted in democracies may be myth. Under certain conditions, tokenism may be so deeply embedded in institutions that desirable change cannot be won without at least some disorder. It is important to stress, however, that I have not argued that disorder *alone* ever has or can bring about redress of legitimate grievance most efficiently. In fact, disorder may, as I believe, best be viewed as occasionally useful as a means of catalysing electoral effort, or, in other ways, as ancillary to peaceful democratic struggle.

Of course, one can trivialize the claim that peaceful change is always possible by insisting that the possibility of bringing changes about peacefully cannot, in the long run, be discounted. This would be a trivialization first, because the same is true in any political system; and second, there is no effective way to test an historical prediction that opportunities for peaceful social change are bound to develop after an indefinitely long period of time has elapsed. This is the conservative converse of revolutionary belief that, in the long run, violent revolution must destroy every capitalist society. In any event, that all good things will come about peacefully in the long run if only one is patient does not establish that one should always be patient. And this is the main point at issue.

III

I have argued that membership in a democracy yields only a very weak reason why disorder ought to be rejected as a means of achieving desirable political change. It does not follow that disorder within democracies is ever morally justified. But I have also suggested an analysis that not only suggests why so many democrats are so casual about the case against disorder, but also makes plain that the moral suitability of disorder may be much greater than they like to think.

At the same time I have not argued that democracy ought to be abandoned as a useless instrument of social progress. Quite the contrary, democracy, especially in the more industrialized societies, seems to me to be an extraordinarily versatile and important in-

strument of basic change. But though democratic process has generally mitigated the amount and nature of disorder required to bring about desirable changes, disorder has often been useful, even necessary, as a means of catalysing democratic pressures for those reforms. For the threat of disorder combined with its occasional use has enabled "moderate and responsible" leaders to urge legislative action by pointing at disruptive elements and warning, "If you don't respond to our reasonable demands for peaceful democratic change you will have to deal with a rising level of disorder." And this threat inspires a lessening of one's natural reluctance to trade social advantages for social peace—a fact Hobbes would have understood very well.

These last comments are, however, a digression from the main claim: that membership in a democracy provides almost no special reason for rejecting disorder as a political tactic.

NOTES

1. "In Pursuit of Equity: Who Serves When Not All Serve?," Report of the National Advisory Commission on Selective Service to the President of the United States, Burke Marshall, Chairman (U.S. Government Printing Office, Washington, D. C., 1967), p. 50.

2. Letter to Samuel Kercheval, September 5, 1816, in *Jefferson: His Political Writings*, ed. Edward Dumbauld (New York, 1955), p. 98.

3. In research done for the National Advisory Commission on Civil Disorders, a substantial majority of those polled favored providing more money for black Americans if that is what is "necessary to prevent riots." A majority was also willing to absorb tax increases of 10 percent to pay for these programs (cf. Angus Campbell and Howard Schuman, *Racial Attitudes in Fifteen American Cities* [New York, 1968], p. 37). Mounting evidence that this sort of ambivalence is pervasive provides empirical underpinning for my speculations.

Comments

FELIX E. OPPENHEIM

I am in sympathy with most of the goals which Professor Kaufman considers desirable, and I am in agreement with most of his rebuttals of the arguments against political acts of disorder in a democracy. There are, nevertheless, two reasons which lead me to the conclusion that it is in general morally wrong to adopt violent means to reach desired ends, at least in a democratic system.

I

The first reason has to do with Kaufman's use of the term "desirable." What are "desirable" changes, "preferable" alternatives, "legitimate" grievances? I disagree with Kaufman's using these adjectives as if they referred to objective characteristics. I, too, do not want here to enter into meta-ethical controversies. Let me simply register my agreement with the value non-cognitivists, that intrinsic moral judgments are expressions of subjective moral commitments. Now, this meta-ethical view has a direct bearing on the central question of Kaufman's paper.

Nobody could deny Kaufman's statement that "if . . . disorder is more likely to involve less harm than a peaceful alternative, then the disorderly route is the one that ought to be traveled" (p. 44). Conversely, if the costs of violence outweigh the positive utility of the goal, violence ought to be avoided. So far, Kaufman merely admonishes us to decide rationally, i.e., to predict as best as possible the total outcome of each alternative open to an actor in a given situation, and to evaluate each of these possible outcomes by taking into account all its elements: means, ends, side effects, and ulterior consequences.

The rationality of a decision in a given situation can indeed, at least in principle, be determined objectively, but only relative to the actor's own standard of evaluation. What positive or negative utility to assign to each predicted element is a matter of subjective preference. According to this criterion, any choice, including or excluding disorder, would be morally right, provided only that it is a rational one.

Several actors in the same situation who all apply the canons of rational choice may arrive at different evaluations. One person or group may value democratic procedures so highly and consider disorder so costly that he is willing to pay the price of a slower progress toward equality of opportunity, or even to pay the price of forgoing the latter goal altogether (assuming that he values it positively in the first place). Others may consider greater equality gained violently preferable to inequality maintained democratically. There is no objective criterion by which to assess whose evaluation is morally right.

This leads me to ask Kaufman the following question: Is it his view that it is morally right to use violence to bring about a goal which is not "desirable," but desired by Kaufman himself, provided that the decision to do so is rational? If so, he must concede the same moral right to any rational actor who adopts different goals. Kaufman is morally obliged to take this tolerant position for the simple reason that moral principles must be, as a matter of justice, universalizable. Kaufman holds this argument to be "unsound" (p. 35), but does not consider this the place to show why. Since I agree that to examine the validity of the principle of universalization would lead us far off our subject, I merely state my view that this principle follows from that of distributive justice, i.e., of equal treatment for all. Whoever is committed to the latter is bound to accept the former. Either nobody is morally justified to pursue his political goals by violent means under democratic institutions, or everyone is. If we subscribe to the latter alternative, we must concede this moral right to John Birchers as well as to Black Panthers, to Chicago police as well as to Berkeley students, to hawks as well as to doves. All are then morally entitled to use disorderly

paths to attain their respective ends, provided the costs of disorder are not too high *by their own estimation.* Otherwise, what moral right does Kaufman have to impose his own values—which are also mine—on others? According to Kaufman, those committed to the principle of universalization must hold that political disorder is either legitimate in every society, or wrong under all political conditions. It is true that "someone who acknowledges a commitment to democracy is under an obligation to reject disorder as a means of pursuing his political goals" (p. 34), and that "someone committed to an autocratic regime would have the same obligation to abide by the results of the autocratic process" (Ibid.). But someone living under autocratic rule who is committed to democracy is under no such obligation. The principle of universalization is compatible with the view that *nobody* may use violence in a democracy, and that *anyone* has the moral right to overthrow an autocratic regime in order to establish a democratic system. By the same principle, opponents of Western democracy, e.g., Soviet communists, can of course maintain that disorderly political conduct is wrong in Soviet Russia or in Czechoslovakia today, but that it was right to bring Czechoslovakia forcefully back into the Soviet fold when it was about to fall under Western democratic influence.

That everybody may use force under certain conditions and nobody under others is compatible with the principle of equal treatment for everybody; approving of violence when used by *some* persons or groups but not by others in the *same* situation violates it. I surely disapprove of those who, under democratic conditions, use disorderly means to ends of which I disapprove. As a matter of justice, I must also condemn disorderly paths leading to goals to which I myself subscribe. I have then no choice but to adhere to the maxim that nobody ought to use force in a democracy for the promotion of whatever goal.

II

My other reason for considering disorderly political activities to be in general wrong in a democracy is a pragmatic one. Kaufman

points out that it would be mistaken to assume that, in a democracy, a peaceful path "will invariably, in every . . . situation, involve less harm than some disorderly alternative" (p. 46). I agree, and my disagreement with Kaufman is perhaps only a matter of emphasis and degree. For I would argue that in *most* democratic contexts, the total outcome of disorderly political action is *most likely* to be more harmful than the total outcome of some peaceful alternative. Again, I share Kaufman's concern about the difficulties involved in estimating the probabilities of consequences of alternative courses of action in the realms of politics in general, and "of balancing the costs involved in peaceful, but slow, against rapid, but disorderly, redress of legitimate grievance" (p. 49) in particular. However, this difficulty seems to me a sufficient ground for caution. To say that "social instability hurts business, jeopardizes personal security, damages the political prospects of office holders" (p. 50) seems to me quite an understatement. We know from history that violence, once unleashed, is in danger of getting out of control. Furthermore, violent actions are more likely to be impulsive than based on rational cost-benefit estimates. Violent actors are generally out for revenge or personal advantage, and not motivated by disinterested desire for greater justice for all. Their victims are often the innocent ones, who are neither responsible for the status quo, nor even its proponents. Fanaticism leads to counterfanaticism. That riots and other disorders have sometimes preceded certain reforms does not prove that the latter occurred because of the former, and that they would not have been brought about otherwise, and within the same time span. Even in cases in which the *probability* that disorder will be more harmful than peaceful behavior is small, the *negative utility* of the former alternative is bound to be so great (i.e., its effects so disastrous) that it is rational to take the latter course.

I agree with Kaufman that in an imperfect democracy like the United States at present, underprivileged minorities who have the most vital interest in political change are in fact excluded from

effective participation in the political process, and that the alternative of peaceful change is therefore practically closed to them. For this reason, the poor or the blacks might well be morally entitled to exert violent pressure to achieve more adequate representation in Congress, local government, trade unions, and other organizations. Suppose, however, that the United States, with its present economic, social, ethnic, and racial divisions had become an ideal type democracy in which all segments had the opportunity to participate in the formation of policies, at least indirectly through election of representatives who actually "represent" their interests and through membership in democratically organized voluntary organizations. Yet, their grievances would still be those of a minority, and their proposals, while now receiving a fair hearing, would be outvoted by the same majority of those opposed, or at least indifferent, to greater economic and social equality. Even so, in a full-fledged "participatory democracy" such deprived and outvoted minorities would hardly be justified to engage in disorderly activities. (This illustrates Kaufman's point that a fully democratic political system is not a sufficient remedy against all social ills.)

I also tend to agree with Kaufman that disorder may be "*occasionally* useful as a means of catalyzing electoral effort, or, in other ways, as *ancillary* to peaceful democratic struggle" (p. 51, italics added). Democracy does not rule out disorder as a way of influencing voters or of persuading elected officials to adopt certain policies within the framework of representative institutions. This case must be distinguished more explicitly than Kaufman does from the use of violence by circumventing democratic procedures—always morally illegitimate in my opinion. Far from believing that the majority is always "right," I value democracy, with the risk that the majority may favor policies which I oppose, more highly than any preferred policy imposed on the majority at the price of destroying democratic institutions.

Let us try to narrow the gap between our present political system and an ideal democracy. For that purpose, peaceful demonstrations

and even civil disobedience are often morally justified, and disorder as a means of influencing elected officials may sometimes be legitimate. But let us abide by the "rules of the game" of democracy. If the choice is between democracy *or* disorder, democracy is by far the lesser evil.

Philosophy and the Critique of Law

RONALD M. DWORKIN

There is at present great dissatisfaction with law and its enforcement in the United States. Criticism comes from two sides. Critics of the law accuse it of being archaic, unjust, and discriminatory; they cite the draft laws that supply men for the Vietnamese war, the scheme of property that forces the very poor to live in ghettos, and the political structures that deny large numbers of people effective participation in the institutions that govern them. Critics of law enforcement, on the other hand, are offended by the tolerance that legal officials—ranging from attorneys general to college presidents—sometimes show to those who break the law.

Both sets of critics present the issues they raise as part of a larger issue, namely the issue of whether law, as an abstract institution, is a good or a poor thing, and the extent to which citizens have a moral or political obligation to obey it. The radicals (as I shall call them, for shorthand) believe that the injustice of particular laws reflects defects in the nature of law, and they oppose the assumption that society should be governed in accordance with fixed general rules that are necessarily, in their opinion, blind to moral discriminations and so unnecessarily restrictive of human freedom. The conservatives, for their part, see in particular acts of disobedience a challenge to the general authority of law, and they therefore believe that tolerating dissent is the same thing as condoning lawlessness.

So the assumption that these political disputes necessarily involve a trial of the value of law is common ground. It is also, I think, a common mistake, and one that is dangerous because it obscures the disputes, and hides certain forms of accommodation that are in fact attractive. In this essay I want to show how much the common as-

sumption depends upon one particular theory about the nature of law, a theory that both radicals and conservatives seem to accept. I mean the positivist theory that has been set out, in different forms, by the great legal philosophers John Austin, Hans Kelsen, and H. L. A. Hart. According to this theory the law of a community is a set of rules adopted in accordance with stipulated constitutional procedures—in the United States this means rules enacted by state or federal legislatures, or adopted by courts, or established by custom, in conformity with the rules of the state or federal constitution. These rules are always more or less vague, and in any event they cannot anticipate all cases that may arise; it follows that in some cases, the law, so conceived, will provide no clear answer to some novel legal question. In such cases the judges and other officials who enforce the law must supplement the rules, even though retroactively, with a piece of fresh legislation.

The law, with this conception, is morally neutral, in the sense that any rule adopted by the proper institution or official will be law without regard to its moral quality. In the United States, this last statement is qualified by the fact that the federal constitution invalidates statutes that offend constitutional rules, and some of these constitutional rules, like the rule that the government cannot abridge freedom of speech, happen to have a moral quality. But the constitutional rules are themselves vague, and leave open the issue of whether in close cases a statutory rule is valid; that is, it may be doubtful whether obscenity laws do abridge freedom of speech. In such cases the judge must also legislate to close the gap, and his decision becomes law without regard to its moral quality.

Some readers will be surprised that I describe this positivist view of law as generally accepted. After all, a great many American lawyers, inside the law schools and out, have rejected Austin, Kelsen, and Hart as unrealistic. But this rejection is deceptive, for the disagreement runs to complementary issues and not the theory of law I sketched. Some American lawyers (particularly those who think of themselves as "Realists") believe that Hart, for example, underestimates the degree of vagueness of most legal rules, and the ex-

tent to which judges who cite these rules are actually enforcing their own social or political theories. The Realists think that judicial legislation is more frequent and broader than Hart allows, a difference that at least in part reflects a difference between American and English practice. But when they speak of the law or of legal rules, even to reject the idea that these play a dominant role in influencing official decisions, they use Hart's positivist conception of what the law is, and so do those more numerous lawyers and citizens who debate the merits of civil disobedience even though they have never reflected on abstract questions about law and morals.

In order to show the power that the positivist theory has exercised in the political debates, I shall outline an alternative theory of law, and then consider how the debates would differ if this alternative, rather than the positivist theory, were generally accepted. I shall not provide arguments to show that this alternative theory is a better theory of law than positivism, though in fact I think that it is.[1] In this paper I am interested only in the contrast between the two theories, and the bearing of each theory on the political debates.

I shall begin my outline of this alternate theory by trying to clarify two central concepts that the theory employs. These are the concepts of a social right and a social obligation. They combine what I shall treat here as two separate ideas: the idea of a moral right or obligation, in the strong sense of those terms, and the idea that at least some moral rights and obligations arise out of social conventions or institutions. When I speak of the "strong sense" of right and obligation I mean the sense in which terms are used to make a specially forceful sort of moral judgment. Saying that someone has an obligation to do something, in this strong sense, means that he must do it, which is more than saying simply that he ought to do it, or that it would be generous of him to do it. Saying that someone has a right to something, in this sense, means that he is entitled to it, and may properly demand it, not merely that he ought to have it, or would be better or happier if he did.

It is a familiar idea that claims that men make about rights and obligations are often based on the authority of social conventions, like the conventions of promising, personal security, and privacy. The claim that someone has a right not to have his mail read or his person touched, or that someone has an obligation to keep his word, are examples of such claims, which I shall call judgments of social obligation. I do not mean to argue that all claims of right or obligation, in the strong sense, are judgments of social obligation, that is, that they all depend on social convention in this way. This may be so, as some philosophers think, but the theory I shall describe assumes only that some judgments of right and obligation are based on social practice in this way; it is these judgments that the theory describes as playing a role in legal reasoning. As I shall explain, the theory holds, for example, that judges must take into account the principles and excuses of promising when deciding difficult contract cases, the principles of privacy in novel tort cases, the conventional principles of property in fundamental cases of title, and so forth.

But some judgments of social right and obligation are a great deal more complex than simple appeals to acknowledged social conventions like promising and privacy, because these conventions are not the only social practices that are relevant to such judgments. In addition to these first-order practices (as I shall call them) the members of our community follow second-order practices that furnish conventions for criticizing and applying first-order practices. Some of these conventions deal with hard or uncertain cases. They provide, for example, that if it is unclear whether someone has an obligation under a particular practice, it is relevant, in reaching a decision, to consider the point of the practice, that is, the principles or policies the practice might be said to serve, and also to consider the impact of other policies to which the community is committed. So if the question arises whether I am entitled to spy on someone else for his own good, I would be expected to support my view with some appeals to the point of the conventions at stake,

and the point of whatever other responsibilities towards him I may claim to have. Other second-order conventions are critical, and furnish grounds for disavowing obligations. One of these, for example, is the rule that a pointless first-order practice cannot impose genuine social obligations, even though those who follow the practice believe that it is binding on others. Suppose that the community follows the practice that each man must participate in rain dances, or play his part in some defense scheme, but a minority thinks these practices pointless. (They think, that is, that the practices cannot achieve the policies they aim at.) Members of that minority will not believe that they have any duty to follow the practices, though they may do so out of politeness or fear. Most members of the majority will agree with the minority to this extent: they will agree that *if* the minority were right as to the pointlessness of the practice in question, then the minority would be right on the issue of obligation as well. Another critical convention is the principle of fairness, though this is much harder to explicate. One aspect of this principle is the proviso that if some group is systematically excluded from the benefits of a practice, through no fault or because of no relevant disability of theirs, then the practice cannot impose genuine obligations upon members of that group. So if a frontier community follows a practice of mutual defense, which stops short at a certain distance from the town, the community cannot expect those who live beyond the area of defense to participate in protecting those who live within.

These critical principles are most important when their application is controversial, that is, when the bulk of the community thinks that a practice does serve some point or does benefit a minority group, but others disagree. The critical principles exist because the majority respects them in the abstract; but they would serve no function unless it were generally recognized that the majority might be wrong in judging whether they apply in particular cases. If this were not generally recognized, the critical principles would be su-

perfluous. If the majority's view settled the question of when a critical principle applied, then the existence of a social practice—whether rain dances or racial segregation or the demand that those outside the defense perimeter help protect those within—would prove that it infringed no such principles.

These second-order practices insure that some arguments about social obligation cannot be settled by one side proving beyond question that the other is wrong. There is no master rule or test that can be used to demonstrate mathematically that a given critical principle applies to a given case. Each man must make and act on his own judgment, and must apply his own understanding of the principles and policies in question. That does not mean that individuals have discretion to act as they please in hard cases. It means rather that the institution of social obligation (by which I mean the general practice of making and responding to particular claims of social right or duty) requires individuals to assume that they have rights and obligations even when these cannot be proved with certainty, and to act on their judgment that the case in favor of a particular obligation is stronger than the case against, even when others will disagree. It is true that this institution would fail and lapse unless the range of disagreement in understanding within the community were relatively small. The range must be sufficiently small so that particular disagreements can be argued against a background of general agreement about what is a good and what is a poor argument. Disagreements must for the most part be disagreements about where a balance should be struck, not about what should be weighed. The former sort of disagreement may be as bitter as the latter, of course, because opponents will see each other, not as representatives of alien cultures, but as men blind to discriminations within their own.

This is hardly an adequate account of the concepts of social right and social obligation, but it may be sufficient to allow me to describe the most important differences between positivism and the alternate theory I want to present. That theory offers a substantially different account from positivism of the reasoning involved in

deciding whether someone has a particular *legal* right or obligation on particular facts. According to positivism, this question is decided by checking to see whether the appropriate legal institutions have enacted a rule that fits these facts, or whether such a rule has been developed by custom. If a rule with that pedigree is found, the legal rights and duties are as that rule provides; if the rule is unclear, or it is not clear whether it fits these facts, then the judge deciding the case exercises his discretion to clarify the rule or invent a new one. In this view the question of whether a particular legal right exists cannot be uncertain, in the sense in which a question of history or economics can be uncertain. If the rule is clear and clearly applies, then the question is settled; if not, then there is no legal right, and anyone who claims that there is must mean that there should be, or must be predicting that a judge will exercise his discretion retroactively to create one.

With the alternate theory, reasoning about legal rights and obligations is more complex, at least in those hard cases in which no clear rule is available. The theory provides that one must approach these hard cases like doubtful cases of *social* right or obligation, by attempting to identify the principles and policies that the established rules serve, and then interpreting these rules, or designing new rules, in that light. The correct decision is that which best accommodates the medley of these principles and policies, some of which, of course, will conflict with others. There may well be no way of demonstrating beyond question which of several different accommodations is the best, just as there is no way of demonstrating which analysis of historical data is the soundest or which of alternate economic programs is the wisest. Each man who must decide a difficult issue of legal rights, because of his personal situation or official responsibilities, must make and act on his own judgment. It is important to notice that with this theory difficult issues of law are genuinely uncertain, because it makes sense to claim that a legal right exists even when one cannot demonstrate that claim by an iron proof. The theory does not hold, with positivism, that a right does not exist unless it clearly exists; it provides that a claim

of right is proper when the argument supporting the claim is stronger than the opposite argument, even when this is a matter of judgment.

It is true that a positivist might say that judges look to the principles and policies I mentioned for guidance when exercising their discretion. But the alternate theory insists, on the model of social obligation, that the judge must proceed in this way, and it treats the judgment he reaches, not as an act of individual discretion, but as an attempt to establish the existence of a legal right. This, as I shall try to show, is a crucial difference.

Thus, the alternate theory uses reasoning about social obligations as the model for reasoning about legal obligations. But it also, and independently, provides for a more intimate connection between these institutions. It provides that the first-order and critical principles that the community follows in making judgments of social right and obligation are amongst the standards that a judgment of legal obligation must try to accommodate. The weight that must be given to these principles, as opposed to the principles and policies derived from strictly legal sources, varies from case to case, but it is greatest on two sorts of occasions. The first are cases in which the rules established by legislation and precedent seem conflicting and uncertain, and these difficulties are not entirely removed by an inspection of the principles or policies the rules exemplify. The second are cases in which the legal rules make moral considerations relevant, like the provision of the Uniform Commercial Code that "unconscionable" contracts are unenforceable, or the provisions of the United States Constitution, such as the "due process" and "equal protection" clauses, that assume that citizens have inalienable rights but do not specify what these are.

Even in these cases, however, the influence of principles drawn from social obligation is limited by what might be called exclusionary principles. I mean principles, themselves established by legislation or precedent, or drawn from practical features of the process of adjudication, that provide affirmative reasons for not giving legal effect to moral or social rights. The principle that the

law does not recognize mental suffering as a legal injury, and that the courts should not tackle "political questions" (that is, questions of political controversy better left to other institutions to resolve) are both examples of exclusionary principles. These principles are not flat rules separating distinct domains of law and morality. They are principles; one who appeals to them to exclude considerations of social obligation must make an affirmative case for the principle he wants to invoke, and he must recognize that any such principle can be overcome when these social considerations are especially strong or the point of the exclusionary principle only marginally relevant. (In segregation cases the principle about not recognizing mental suffering or insult was overcome for the first reason, and in reapportionment cases the political question exclusion was overridden by the second.)

I shall close this brief summary of the alternative theory with two illustrations. A case I used elsewhere, in a criticism of positivism,[2] illustrates the role the theory assigns to social practices in reasoning about commercial law. The case is *Henningsen v. Bloomington Motors*,[3] and the question at issue was whether an automobile manufacturer should be allowed to limit its liability for defects by inserting a clause to that effect in its standard contract.

The precedents seemed to give effect to such a waiver, but they were not clear and in any event this result seemed unfair. The judge decided not to enforce the waiver. Two judgments of social obligation figured in his decision. The first was the judgment that manufacturers of dangerous objects, like cars, have a heavier social obligation to take care than do manufacturers of neckties, for example, so that the fact that the latter are allowed to exclude liability is not decisive that the former should be allowed to do so. The second was the judgment that an institution has a duty to keep not only the promises it makes in explicit terms, but also those it makes implicitly by its conduct; it follows from this that an automobile manufacturer should be held to the impressions made by its advertising as well as by the letter of its contracts.

These are not exotic or even very controversial judgments, and the crux of the case was not whether they do represent social practice, but whether competing principles, including exclusionary principles, barred them from having any effect. The exclusionary principle most relevant was the principle that only relatively precise agreements count in determining legal obligation; this time-honored principle, which works toward increasing the efficiency of lawsuits, might bar consideration of the vague promises implied in general advertising. But the judge argued, through a careful study of recent precedents in related areas of law, that the force of this exclusionary principle was waning, and was overcome by the powerful effect of institutional advertising, at least on the facts of the present case. It does not follow that the principle would not bar the admission of vague promises in another sort of case.

Almost any controversial case involving the Bill of Rights would illustrate the role assigned to social practices in constitutional reasoning. In the recent case of *Griswold v. Connecticut*,[4] for example, the issue posed was whether the Connecticut law forbidding the prescription of contraceptives violated the United States Constitution. A majority of the Supreme Court decided that it did. Different justices gave different grounds for this decision, but each of the majority opinions appealed to judgments of social right and obligation in some way, and two such judgments played a major part in the ultimate decision. The first of these made use of one of the critical principles I mentioned: several justices thought that the Connecticut law was pointless, because it served no position that could properly be attributed to the Connecticut legislature, given the rest of Connecticut's legislation, and given the principle of the First Amendment that a state may not establish obligations to serve a religious principle. These justices held that the Constitution incorporates this critical principle through the provision that the states' criminal process must observe due process of law. The second (and much more far-reaching) judgment was that the Constitution invalidates state laws that conflict with social rights established by the most powerful first-order social practices. Some

of the justices thought that the social institution of privacy was sufficiently powerful to invoke this constitutional protection, and that the anti-contraception statute infringed the social rights established by that institution, either directly, or indirectly because enforcement of the law would require invading these rights.

That completes my outline of an alternative theory; I hope that some of the more obvious gaps will be filled by the discussion that follows. I want now to list and discuss the various issues, central to discussions about law reform and civil disobedience, that seem to me to depend on whether one accepts the positivist theory of law or this alternative.

1. *What grounds should a judge have for changing the law, either by developing unclear or incomplete law in one direction rather than another, or by repealing an old doctrine outright?* The positivist theory holds that a judge about to lay down a new rule is exercising his discretion, and acting as a legislator. This characterization was originally thought to be liberal, because it recognized the judge's freedom to make new law. But in fact it has suggested, for a great many lawyers who hold the positivist theory, substantial limitations on judicial authority, because the judge's right to act as a legislator is questionable under democratic theory.

Judges are often appointed rather than elected. When they are elected it is generally for a very long term, and in any event we do not expect them to be responsive to public opinion in reaching their decisions. So they do not have the same warrant to make law, under orthodox political theory, that Senators or Congressmen do. That fact is not relevant in the simple, run-of-the-mill lawsuit, which a judge can decide by applying an established, uncontroversial rule of law. In that case the judge's decisions are justified, not on democratic theory, but on the ground that the defendant either did or did not have the legal obligation the plaintiff alleged. This is a different ground from democratic theory because it does not suppose that at the time of the decision either the majority of the people or their elected representatives thought that the defendant should have that obligation. (Perhaps the obligation

was imposed originally by a statute, but the statute need not represent the will of the majority at the time it is applied by the judge; indeed it might have been repealed between the time of the transaction or event in question and the time of the actual lawsuit.)

But on the positivist theory this alternative justification—that the defendant did or did not have a legal obligation—is unavailable in a hard case, because in such a case, by definition, no such obligation exists. The judge must therefore act as a legislator in spite of the fact that he does not have the legislator's warrant, and that means that he must show deference to the legislature as an institution with superior title. That is, I think, the ground of Oliver Wendell Holmes' injunction that the judge must legislate interstitially, between the cracks of what the legislature has done, and of the popular theory that a judge faced with a hard case should decide as he supposes the legislature would decide. It is also a major source of the doctrine of judicial restraint in Constitutional law, because according to positivism a judge interpreting an unclear passage of the Constitution is legislating just as much as a judge filling in the chinks of the Internal Revenue Code, and his warrant is even less clear because the legislature cannot overrule a constitutional decision it disapproves, as it can overrule a disagreeable interpretation of the tax law. Learned Hand, in his brilliant and pessimistic lectures on the Bill of Rights, spoke as a positivist when he criticized the Supreme Court for acting as a super legislature. He meant that if the court was to legislate Constitutional law it must do so as a junior rather than a senior partner, and must try to allow the legislature the last word on what the Constitution means.

This view of the court's function not only encourages restraint, but also affects substance. It presses the judge, when he does change or develop the law, to look to the majority's interests or inclinations, because the legislature is the creature of the majority. That is not necessarily a conservative bias. In the 1930s, when positivism made great advances in the law schools of this country, the existing law in many instances favored a privileged minority, and the goal

of reform was majoritarian equality. The theory that judges should decide novel cases with the interests of the majority at heart was therefore attractive to liberals.

Now, however, those who worry about social justice are not concerned with recognizing the majority's title to rule, but with protecting the rights of minorities against a majority bent on serving its own interest. Some liberals argue that this is a false contrast, and that the best interests of the majority lie in granting what the minorities ask. But that is a pious hope, and it rings false.

The alternate theory takes a very different view of the judge's role in hard cases. It does not draw a sharp line between easy and hard cases, as positivism does; instead it makes available for hard cases the same warrant the judge has in an easy case, that he is doing his best to enforce rights and obligations whose present power is independent of the majority's will. This warrant has the opposite force from the democratic warrant in the cases I just mentioned, when a minority is urging its social rights in its own terms, and the fact that the minority is unable to point to an established legal rule recognizing that right does not, for the reasons I gave, dispose of the issue. Even when the case is a constitutional one (as it may well be when the interests of a minority are at stake) a court may be bold, if it thinks the minority's claims are sound. The court should be sensitive to the views of the legislature and the public at large, on prudential grounds, and because it would be wrong to be arrogant in matters of judgment. But it need not consider itself a junior partner in the enterprise at hand. It need not fear being called a super-legislature, because its warrant does not depend upon its being called a legislature at all.

2. *What can it mean to say that a court, in a hard case, has made a mistake?* This second question need not detain us long, because its answer is governed by the answer to the first. On the positivist theory such a mistake cannot be a mistake of law, any more than a legislature's ill-advised statutes are mistakes of law. If the Supreme Court interprets the equal-protection clause of the Constitution in a way that disappoints me, I can give reasons why

a different decision would have been fairer, or more efficient, but I cannot claim that the decision deprived me of anything to which I was legally entitled.

On the alternate theory, however, I can make this claim. I can say that the court made a mistake of law, and deprived me of my rights, even though I have to admit that the issue was a close one and that reasonable men may agree with the court and disagree with me. I mean that the arguments supporting my view of the best accommodation of the various legal and social practices are stronger than the court's arguments. If I do take this view, however, then even under the alternate theory I must accept two caveats:

A. Insofar as public officials (like the sheriff) must take a view of the law in dealing with me, they are obliged to proceed on the court's view rather than mine, not because the court's view is necessarily right, but because there exist independent rules of law that make the court's view count for these purposes, right or not. There are occasions, nevertheless, on which public officials may but need not take a position on the law; on these occasions they might well take into account the fact that I have a bona fide disagreement with the court as to what the law is. One such occasion arises when I have broken the law on the prosecutor's view but not on mine, and he must decide whether to exercise his discretion to prosecute me.

B. Because of the practice of precedent, the court's view, even if wrong, becomes part of the sources which I must take into account in making fresh judgments of law in the future. When I make my calculations again, that is, I must take into account something that was not present before, namely the court's decision itself. Depending on the issue, and the rank of the court, this additional fact may or may not make the difference. If this issue was one of interpreting a provision of the tax law, and the Supreme Court found against me, then I would be forced to conclude that the decision, though wrong, had changed the law for the future. But if the issue was one of religious freedom, and the Supreme Court held that I might properly be forced into an act that infringed the tenets of my faith, I might well be justified in holding

to my contrary view even after the court's decision. The difference between tax cases and civil rights cases is a difference established by the practice of precedent itself; the Supreme Court recognizes that it is bound by its own past decisions to a greater degree in tax cases than in cases affecting civil liberties.

3. *When is it accurate to say that someone rejects the moral authority of law?* This is not a difficult question on the positivist theory. Under that theory one can draw a sharp distinction between legal and moral obligation, and say that a man who disobeys a statute on moral principle is challenging the moral authority of law. There are two different pictures such a man can take. He might recognize that the law generally imposes a moral as well as a legal obligation on him—he might accept, that is, a moral obligation to obey the law as such—but he might make an exception from time to time, and not regard a particular law as morally binding if it is affirmatively objectionable on strong moral grounds. Or he might object to law as such, and not recognize even in principle a moral obligation to obey it.

These distinctions, and the concepts they employ, have dominated discussions about civil disobedience and the challenge to law. The liberal, opposed to the war in Vietnam, thinks of himself as taking the first posture of disobedience. The radical, hating the institution of property, thinks of himself as taking the second. The conservative recognizes the distinction, but claims it is irrelevant for purposes of punishment because in either case the law is the law and a dissenter is an outlaw. All three are aware of the fact that a law may be unconstitutional, but they regard this as a possibility to be excluded by hypothesis when civil disobedience is in issue. If the law being broken is unconstitutional, then it is no law, and the problem of civil disobedience does not arise. So the discussion must concentrate on these cases in which there is no doubt of constitutionality, or in which the courts have settled the issue in favor of the law.

But these distinctions cannot be made, so clearly at any rate, on the obligation theory. The root distinction between moral and legal obligation does not hold. Instead we must recognize a number of

different sorts of cases of disobedience on principle. Suppose, for example, that a man believes that a statute is unconstitutional, even though the courts have held to the contrary. It is too simple to say that this man, if he refuses to obey the statute, is rejecting his legal obligations, and just wrong to say that he evidences an attitude of hostility to law. On the alternate theory the court's decision does not necessarily make his view of the law wrong. To report his case with any accuracy, we should have to distinguish between his attitude towards law and towards the skill or, possibly, the authority of the courts. (I say "possibly" because, as I said, the courts themselves refuse to take their past decisions as necessarily controlling their future ones, particularly when important social rights are at stake.)

Suppose, to take a different case, that someone refuses to obey a statute on the grounds that it infringes some fundamental social right, such as the right to privacy or security, and the Supreme Court has refused to consider whether the statute is constitutional. Or suppose the Court has held the statute constitutional by appealing to an exclusionary policy, like the political question doctrine, or the doctrine that the courts should not adjudicate issues involving special competence in, say, military affairs. Even if the dissenter agrees that the Court acted properly in disposing of the constitutional issue in this way, it is again too simple to say that he is rejecting the moral authority of law; we must say instead that he rejects the adequacy of adjudication, with its limitations of institutional competence, as a final guide to what his legal rights and duties are.

A positivist might want to say that this is nonsense because the prudential exclusionary standards are also legal principles, and if a dissenter does not recognize these as binding on him as well as the courts, then he is challenging the law. It is true that exclusionary principles are legal, in the sense that a court must take them into account, but the alternate theory encourages us to distinguish the different strands that enter into a judicial judgment. It is important, when reporting someone's attitude about law, to distinguish

policies that have to do with prudent adjudication from principles, drawn from statutes, precedents and conventional morality, that express the nation's convictions about how its citizens shall behave and the rights they shall enjoy. If someone appeals to these latter standards to justify his behavior, it misses the heart of his attitude to say only that he is challenging the law on moral grounds. It is vital to add that his grounds are the fundamental principles of the law itself.

But what about the radical who takes the position that the whole of the law is rotten and deserves no respect? Surely it is accurate to say that this man is challenging the institution of law as such? I am not so sure, even here, because this flat statement might hide some important complexities. We must ask for the radical's grounds for condemning the law. Suppose that these involve the charge that our laws and institutions systematically deny important rights, like the right to equality, or dignity, or survival, or self-expression. Suppose, further, that his arguments in favor of these rights appeal to first-order or critical social practices, as they well might. He might appeal, for example, to the traditions of the nation, better exemplified in its earlier days. Or he might argue that the law fails to enforce rights recognized socially, or fails to extend to a minority group rights extended by the majority to its own members. If so, then on the alternate theory the radical's point is not well stated in the proposition that all law is corrupt. He is in fact arguing that the community's law is inconsistent, because a great many of its particular rules conflict with the social institutions and conventions on which the law is supposed to rest, and neither the courts nor the profession have recognized the conflict.

I know that the radical hates what he calls conventional morality as much as he hates what he calls law. But he may well mean by conventional morality only popular morality—the majority's views of what its rights and duties are—and not the complex social institutions and critical practices I have tried to describe. Still, it would be wrong to define the thorough-going radical out of existence. I assume that there are at least some radicals who would take

it as a point of pride to reject social practice of any sort as relevant to their claims, and in the next section I shall describe some of the difficulties I find in this ultra-radical posture. I am sure, however, that many radicals do not take this posture, and that fewer would do so if they were not forced to choose between accepting popular morality and rejecting tradition and convention altogether.

I hope that no one will think that the argument has now become too speculative, or that I am playing with words in arguing that at least some radicals who denounce law are in fact paying great respect to its ideal. There are important practical issues at stake here. It is common opinion that those who oppose law are anarchists and outlaws who deserve to be treated as such. My point is that some of those who, on the positivist theory, must be regarded as hostile to law are in fact deeply committed to law in what I consider a more subtle and important sense. They are committed to the idea that government should be regulated by principle, and that those who have social power should extend to everyone the rights that they have consciously or habitually claimed for themselves. On the alternate theory that proposition is the heart of the rule of law; in any event it is the very opposite of anarchy. To call those who hold and act on these views outlaws is a distortion that must cripple our ability to understand and respond to what they say.

4. *When is one justified in rejecting the authority of law?* We have been discussing when it is accurate to say that someone is challenging the law; now I want to discuss the different issue of whether someone is ever justified in doing so, and if so when. This is a very complex question, and I shall narrow it to this extent. I shall assume that the American community follows a social practice of obedience to law that would give rise, at least in the absence of some competing practice or applicable critical principle, to a social obligation to obey the law binding on all its members. Many radicals claim that that social obligation has in fact been erased by some such competing practice or critical principle; I shall try to describe the impact of our two theories on that claim. I shall not consider the issue of whether one would have a moral obligation to obey the law, even if the social obligation had lapsed,

or whether one has a moral right to disregard the social obligation even if it has not lapsed. While each of these two last claims has been made, the bulk of the radical arguments now current, as I shall try to show, are aimed at providing that the normal social obligation to obey the law has been wiped away by one or another sort of political injustice.

The assumption I just named, that one has a social obligation to obey the law, unless that obligation has been removed by some critical principle, follows easily from both the positivist and the alternate theories. Positivism traces the authority of all law to a fundamental social practice, namely the practice of accepting and obeying rules created in accordance with the master rule. If there is law in a community, according to positivism, some such practice must exist, and if the law is at all stable that practice must be spread throughout the bulk of the community. But if a general social practice of this sort exists, then members of the community have a social obligation to follow it, just as they have a social obligation to follow the practices of privacy or mutual defense, unless some critical principle applies. The alternate theory denies the existence of any one fundamental practice, but it traces the authority of law to the combination of several social practices: the distinctly legal practices of legislation and adjudication working in concert with the underlying practices of social obligation. It is therefore quite redundant, on the alternate theory, to say that one has at least a prima facie social obligation to obey the law, for the law on this theory is the consequence of a set of social obligations. On both theories, however, the social obligations that the law represents can, at least in theory, be overcome if the law is unjust, and this is the background of most radical attacks on law. These attacks typically appeal to the critical principles of fairness; they argue that the institution of law constitutes a discrimination against minority groups within the community, pressing disadvantages on these groups for the sake of others.

The general acceptance of positivism affects these arguments in the following way. The notion that the authority of law rests on one fundamental rule has two consequences. First, it focuses the

attack on law on the strictly legal practices and institutions that the master rule designates, for if these can be shown to be unfair it follows that one has no social obligation to obey any of the particular rules generated by these institutions, even those that are not unfair in themselves. Suppose a critic is persuaded, for example, that the legislature of his community is unfairly constituted, because his group is unrepresented, and that the courts, staffed by men from more affluent sectors, are insensitive to the special needs of that group. He might well feel justified in rejecting the practice that transforms the decisions of these institutions into social obligations, and treating that practice as we should treat any social practice we regarded as discriminatory. If he were a positivist, disposed to rest the social obligation to obey the law on the authority of these institutions, he might conclude that this social obligation had been cut off at the source, and that he had no obligation, by virtue of membership in the community to obey even those laws that he did not consider discriminatory, like the rules outlawing theft or violence to property.

Second, the assumption of a master rule neatly separates the social obligation to obey the law from other social rights and obligations, and so permits the radical consistently to reject the former while insisting on the full enforcement of the latter. He may argue that he has no duty to obey the laws of trespass, because the entire law is corrupt, and yet insist that society has the duty to recognize his right to security, privacy, or equality; indeed his arguments that the whole of the law is corrupt may depend in part on the claim that it does not recognize these rights. If legal and other social obligations were thought more interwoven than positivism allows, his position, while not necessarily inconsistent, would require him to show why the features that invalidate legal obligation do not also infect the other obligations he cites.

So positivism, which, as I argued in the last section, encourages the view that someone who disobeys a law on principle is challenging the authority of law wholesale, improves the case that one might have for making such a challenge. The alternate theory, on

the other hand, discourages that characterization, and complicates that case. If one accepts the alternate theory, he cannot argue, from the unfair composition or performance of any one institution, that the obligation to obey the law is cut off at the source. He must recognize that the legal institutions operate against a background of social practice and convention that supports and confines them, and guides the interpretation of what they do. If there were not an elaborate social system of respect for property, for example, structured by a set of rights and obligations independent of the law, then the law of trespass, for example, would constitute an inconceivable—and unconstitutional—infringement of personal liberty. If there were no statutes dealing with trespass, on the other hand, then the courts would still enforce at least the most important of the social rights at stake, not because a court is really a legislature, but because these rights are sufficiently important that the courts would have to recognize them, on the alternate theory, notwithstanding the exclusionary principles. Of course, the social practices of property are much strengthened by the fact that they have been codified in statutes and enforced by law, and perhaps they would no longer exist if legislatures and courts had tried to stamp them out. But that shows the historical interweaving of legal and social practice, not the formal dependence of one upon the other. So it is a fallacy to argue that because the legislature is unfair, one has no social obligation to respect the law of property. That argument neglects the fact that the law of property is supported by a great deal more than the legislature's fiat.

This fact does not, by any means, prove that the laws of trespass represent genuine social as well as legal obligations. It does mean that there is no short cut to proving the contrary. The conscientious radical, on the alternate theory, has two options if he wishes to deny that obligation. He may, on the one hand, dissect the social practices that support these laws, attempting to show that these social practices themselves conflict with other social rights or with critical principles the community has otherwise established. If he takes this tack, he will no longer seem so radical, because he will be accepting

the fundamental principles of social obligation and criticizing particular features of that institution from within. Or he may, on the other hand, renounce the institution of social obligation altogether, relying on some personal or transcendental morality to condemn the very idea that social practice, even monitored by critical principles, can bind men. If he does this, however, then he runs the danger of undercutting his own position. He will then not be able, consistently, to make demands on the community by appealing to social rights or duties; he will not be able, for example, to argue that the community has an obligation, under its own conventions and critical standards, to improve the lives of minority groups. He may, of course, find other bases for argument—or he may not feel that he needs argument—but the appeal to social obligation has been the mainstay of political rhetoric for a long time.

It may seem naive to suppose that effective radicals—or liberals or conservatives, for that matter—are sensitive to jurisprudential nuances, or that they will act or argue differently depending upon which theory of law gains their favor. It is impossible to say to what extent argument alters political convictions; this question, like other questions of individual and social motivation, is so entangled in conceptual confusion that it is not even clear how we might begin to answer it. It is clear, however, that persuading opponents to change their minds is not the only function of argument. Being prepared to reason and argue is part of the posture of having principles and acting on principle; one cannot claim to be a liberal, or a prohibitionist, or a Marxist unless he accepts a commitment to whatever has been shown to follow from these faiths. He may disagree that some particular proposition does follow from his principles, but he can hardly ignore arguments that it does. This fact may help to explain why the tradition of making and criticizing arguments has persisted, and why it has been thought an essential ingredient of principled government, in spite of wide suspicion that political argument changes few minds.

The point is of special consequence now. The United States is enforcing foreign and domestic policies supported by a majority

but deeply resented by a large and powerful minority. We have not, as a nation, indulged in this stark form of majority rule very often, and our institutions and political maxims have not been developed to ease the tensions it generates. Men of good will sense the need for accommodation, but their principles, as they see them, stand in the way. Consistency to principle seems to demand that lawlessness be punished, on the one hand, and that no compromise be made with illegitimate authority, on the other. So political crises are deepened, not entirely because men are revolted by opposing ideologies but in part because they feel committed to their own. It is important to discover whether in fact they are.

NOTES

1. For some arguments that this theory is a better account of our legal system than positivism, see my article, "The Model of Rules," *The University of Chicago Law Review* XXXV: 1 (1967), pp. 14–46.

2. See Note 1 above.

3. 32 *New Jersey Law Reports* 358; 161 *Atlantic 2nd Law Reports* 69 (1960).

4. 31 *United States Reports* 479 (1965).

Comments[*]

GERALD C. MacCALLUM, JR.

I

I find myself in sympathy with two of the main thrusts of Dworkin's paper, though not totally untroubled by the way he works things out.

One of his aims is to convince us that "extreme positions in the debate about law and order have been distorted, and that it is important to try to correct these distortions in the hope of reducing the false antagonisms and posturing they generate." In dealing with this matter, he is right to emphasize a feature of law too often overlooked in these debates, viz., the aspiration to decide cases in a principled way; but in emphasizing it he underemphasizes another more commonly noticed feature and its ramifications, yet for all of that, a feature still present and potentially troubling, viz., the devotion of the machinery of law to terminating cases and controversies. In emphasizing the latter (as I will), however, I shouldn't be taken as challenging Dworkin so much as calling attention to what remains to be done.

Another of his aims is to convince us that the decision of a complex and controversial lawsuit is a matter of bringing together many strands, and that one such strand is moral philosophy. This claim may be true, but it is troubling because he supports it by arguing that a judge may work with and be guided by the moral conventions of his community. Even if this latter were a fact about the law, would it be enough to support the claim that one of the

*These comments, published here with the permission of Professor Mac-Callum, were made on a penultimate version of Professor Dworkin's paper (the editors).

strands brought together in the judge's decision was moral philosophy? Why not say that this strand was instead a piece of sociology or, if you like, a piece of moral sociology? I have questions for the most part here rather than answers, however, because it strikes me that a distinction between sociology and moral philosophy might possibly not be helpful at just this point.

Dworkin's discussion of these matters raises a good many philosophical hares—far too many to pursue profitably here—largely because it is accompanied by an indictment of (legal) positivism. (Furthermore, some of his points are parasitic on other writings of his, most notably "The Model of Rules" [*The University of Chicago Law Review*, 1967] and "Lord Devlin and the Enforcement of Morals" [75 *Yale Law Journal*]). But his principal focus remains on the role in legal thought of appeals to the moral conventions of the community. While his treatment of this topic constitutes a facet of his attack on positivism, it also plays a fundamental role in his paper quite apart from that, and I shall concentrate on it alone. It is the launching pad for his claim that moral philosophy is a strand of legal thought, and also for his claim concerning the essence or idea of law—an essence or idea he believes is or might be missed by many radicals and many conservatives.

II

What role in legal systems does Dworkin claim for appeals to moral conventions? He argues in the present paper only that they enter into the work of judges, though he might of course want to argue more than this on another occasion. He also argues that they enter into judicial decisions in just the way that appeals to legislation and to precedent enter in, though there are or appear to be two important and possibly connected qualifications put on this last: (1) though this is not perfectly clear, he appears to allow more range to the operation of appeals to moral conventions in cases of constitutional interpretation than in cases of statutory interpretation; (2) he claims only that such appeals enter into hard cases—

cases characterized as ones where appeals to legislation and precedent are insufficient to settle matters. I do not wish to attack these claims directly, but rather to raise some questions about what they amount to and what their ramifications are.

A. How are hard cases to be identified? Dworkin says that they are ones where appeals to legislation and precedent are insufficient to settle matters. But this falls short of being helpful just where we require help. He specifies that the only way in which such appeals could fail to settle matters is when the rules "enacted" by legislation and precedent are not sufficiently clear. But his remark at this point certainly suggests that there are other ways as well. What are they? We must know in order to learn something very important, viz., whether the status of appeals to moral conventions is uniformly *subordinate* to the status of appeals to legislation and appeals to precedent. From my reading of Dworkin, I have not been able to decide what he thinks about this. The matter is important not only because we are not in a position to assess his claims about law until we are sure of what they are, but also because we want to judge how far he might be able to reach accommodation with the radicals and conservatives whom he would like to hear his remarks about law. Not that he is committed to comforting or awakening either radicals or conservatives on every point (it is interesting to note that the thrust of his paper is to comfort radicals and awaken conservatives), but we certainly have an interest in getting clear on how far his account might or might not work here. Consider the following question: Are hard cases ever hard precisely because legislation or precedent, though clear, come into conflict with moral conventions, or is the hardness of a case to be determined independently of contemplation of such conflicts? If the latter, and if it is only *then* that appeals to moral conventions come to the fore, then such appeals have only a secondary or backup status, and it is worth considering just how far recognition of this status keeps some radicals and some conservatives apart.

B. The fundamental issue I am raising here is: How are these things put together in a legal system? Dworkin does not ignore

this issue, but it is of treacherously great importance to the whole enterprise in which he engages in his paper, and I do not think that he gives it its due.

It appears in two distinct though related ways.

1. Dworkin identifies as the essence of law the aspiration to decide cases in a principled way, and he spells out fully and elegantly what this means. But, as has sometimes been said, there are principles and then there are principles. It is fine to decide cases in a principled way, but the complaint of some radicals (and the insistence of some conservatives) may be precisely that priority is *not* (to be) given in judicial decisions to principles drawn from the society's moral conventions when these principles conflict with principles or rules drawn from legislation or from precedent. Now, both the radical and the conservative may be wrong here, and they may be wrong in either of two ways: (1) in thinking that the priorities are uniformly as just stated, or (2) in thinking that it is wrong (or right) for the priorities to be wholly or mostly this way. If they think the first, I don't know how one could show them *terribly* mistaken; the issues here seem to me very sticky. If they think the second, then the path of further argument seems a bit clearer to me. But one can approach the whole matter and begin to meet them only by addressing himself to the following question: What *is* the characteristic pattern of interaction between appeals from these three sources, i.e., how is it all put together?

2. A second way in which the general issue comes to the fore is this: Dworkin identifies principled appeals to legislation, precedent, and moral conventions as the essence or idea of law, and suggests that when they do not carry the day it is because of the operation of things such as "exclusionary principles" which are not, he argues, so closely allied to what law is. This strikes me as an error. These latter "principles" have too much to do with the viability of law to be shoved aside in this way.

I agree with Dworkin that law is very importantly an embodiment of an effort to resolve controversies on principles of the sorts he mentions earlier. I agree too that this important fact about law

is too often overlooked by radical critics of law and perhaps also by some conservative critics of radicals. But one must not overlook the fact that legal systems are devoted to resolving (i.e., terminating) controversies. It is characteristic of legal systems that they provide machinery for doing this, and that they limit the extent to which parties to disputes once resolved in accord with the operation of this machinery may obtain access again to the machinery of resolution vis-à-vis those very same disputes. This is the feature of law that is overemphasized by the slogan, "not that cases be decided rightly, but that they be decided." Dworkin is not blind to this, of course, but his introduction of some of the ramifications of this feature of law as mere "caveats" to his main theme, and as exclusionary principles quite disassociated from the essence of law, pushes it too much to one side. (He really does go very far here. For example, he *contrasts* a person's attitude toward law with his attitude toward the competence, "or, possibly, the authority of" the courts, and he *contrasts* a person's rejection of the authority of law with his rejection of "the adequacy of adjudication, with its limitations of institutional competence, as a guide to what his legal rights and duties are.") So far as I can see, the title of this machinery to constitute the essence or idea of law, while certainly no better than the title of Dworkin's candidate, is certainly no worse. When one brings it back into the limelight where, if I am right, it *also* belongs, one can see how crucial is the question: How are these *two* "essential" features of the law (the one to which he has called attention and the one to which I have called attention) put together?

For it is not enough to say to someone that if he values deciding controversies in accordance with principle, then he should notice that this is an essential feature of law and should therefore value law. The question is not only whether the person being addressed finds the principles actually being used acceptable (a question to which we shall return shortly), but is also a matter of how this feature fits with the other I've mentioned into the total character of law.

The pattern of Dworkin's reasoning to radicals and conservatives on this point would, so far as he goes, have to be: If x is an essential feature or part of y and if a values x, then a should value y. But the reasoning would be faulty. The radical, for example, may love the aspiration to decide in accordance with principle just as Jack loves Jill. But just as Jack may not be able to stand the sewing circle of which Jill was a founding member and is a leading and sustaining light, may think that this environment corrupts her, that her interaction with these people at this level is wrong for her, so the radical, though loving the aspiration to principled decision-making, may not be able to stand the law of which that aspiration may have been a founding motive and still be a leading and sustaining light. He may think that the association of this aspiration with the characteristic machinery of the law for bringing an end to controversies—even though the aspiration may have played a role in inspiring the machinery and may, at least in blueprints, play an important role in guiding its use—is a mistake. He may think it is a mistake because, as we know it often does, association with that machinery corrupts the aspiration.

We can deal with this complaint only by painstaking consideration of the details about when and how submission to the outcome of this machinery is demanded in legal systems. I have no wish to suggest that Dworkin doesn't see this; he assuredly does. It is the basis, so far as I can see, for his well-placed doubts concerning the clarity of the borderline between lawful dissent and civil disobedience. And it has enormous ramifications which he assuredly sees for the rationales of the division of function within legal systems (cf. his remarks on how sheriffs or lower courts may rightly proceed on a given court's view of the law rather than the view of a litigant when these views differ). But it is precisely this division of function, so utterly characteristic of legal systems, that makes difficult and complex answering *both* the question as to when and how submission to the outcome of the machinery of the law is to come, *and* the question of what law or the essence of law is. Indeed, it is in the former question that we may find the depths of

some radicals' worries about what they'll be involved in if they accept the accommodations Dworkin offers concerning the nature of law. The radicals may suspect something here, and may want to feel their way very carefully; they may suspect that an enforced demand for submission *ever* in *any* form may poison the wells from which comes the aspiration to decide controversies in a principled way.

III

Turn now to consider some ramifications of Dworkin's discussion of moral conventions per se.

A. It may seem surprising that, with all the emphasis on moral conventions in his paper, he never seems to take as significant or important the possibility of a gap or lack of fit between what the moral conventions of a community are and what they ought to be. One would think that this issue would be of enormous importance to radicals, and, indeed, to judges as well. Dworkin suggests the distinction fleetingly in contrasting social morality with "some absolute" morality. Perhaps we could land at least a close relative of this latter specimen if we consider H. L. A. Hart's contrast between social and rational morality, a contrast characterizing the former as a set of moral views widely or predominantly held in a society, and characterizing the latter as a set of moral views that would withstand critical scrutiny.

I must approach this matter cautiously, because I'm not sure precisely what should be said. But let me start by repeating a remark made earlier: If we allow the possibility of a gap between social morality and rational or critical morality, then there would seem to be an important respect in which one of Dworkin's principal claims would remain incompletely argued even if one conceded that judges do appeal to the moral conventions of their communities in deciding cases. The claim in question is that the decision of a complex and controversial lawsuit is a matter of bringing together many strands and that one such strand is moral philosophy. We should note that the judge has not been conceded to have an in-

terest in critical morality; he has been conceded only to have an interest in social morality and to be guided in part by *it*. This might appear more a sociological strand than a moral-philosophical one in legal thought, though one might argue that it is in the end the latter. This matter, of course, has to do with what moral philosophy is all about, and this is something that needs discussing.

The issues in this area have not emerged clearly in Dworkin's paper, perhaps in part because he operates with a view of moral conventions based on a highly discriminative sense of the word "moral"—a sense he spells out more fully in another paper ("Lord Devlin and the Enforcement of Morals"). I don't want to be unfair by attaching too much importance to this other paper, but a reference he wrote in the margin of the present paper at this point encourages me to believe that he intends what he says here to be parasitic on what he said there. On that discriminative account, moral views (and thus presumably moral conventions) are to be contrasted with prejudices, personal aversions or tastes, rationalizations, and parrotings. In addition, a qualifying condition for a view's being a moral view is that it not be successfully attackable on ad hominem grounds concerning the speaker's (or holder's?) sincerity or consistency. This discriminative sense of "moral," while it has some considerable point, promotes obscuration of the very possibility of a gap between social and critical morality by promoting an identification of social morality with what can withstand critical scrutiny. It threatens to reduce the search for social morality to a search for what will pass such scrutiny—thus, a telescoping of moral philosophy and sociological investigation.

This, it seems to me, raises very deep difficulties, not so much difficulties for Dworkin's paper as difficulties simpliciter. But I will, in closing, connect these difficulties in a highly speculative way with Dworkin's attempt to find accommodation with radicals on the grounds of appeal to the law's aspiration to principled decision-making.

B. Consider his discriminative sense of "moral convention" in the light of the following queries:

1. Suppose that the society we are talking about is the United States as it is right now. How would we meet attacks by ghetto residents or student radicals on some of the candidates for this society's moral conventions suggested by Dworkin's remarks? Remembering the contrast between moral views on the one hand, and simple aversions on the other, and brushing aside the possibility that the standard labels for these conventions might mask very real differences, consider Dworkin's claims about those of "our" conventions on which one can base claims of a right to have someone not touch him or open his mail. I am not clear at all about what ghetto residents might say about these things, but what if they said that Dworkin here has merely elevated some middle-class aversions to the status of moral principles, and that, no matter how much talking we might do about it, the talking would amount to nothing more than a set of rationalizations for these aversions. Could we convince them otherwise? (We would here, of course, get into some difficulties exposed in a previous session—difficulties about levels of relative importance and levels of generality and how they are related.)

2. To go more deeply, look past Dworkin's examples and directly at his discriminative characterization of morality, and consider how we might meet radical challenges to *it*. Consider in particular the possible challenge that it embodies a middle-class demand for, and interest in, articulateness. Is the contrast between moral views on the one hand, and simple "parroting" on the other, a demand for articulateness? Dworkin's discussion of this on pp. 998-99 of the essay just cited is complex, but it seems to me that in the end, in the contrast between moral views and mere parroting, the demand for some sorts of articulateness is there.

Perhaps it should be there. I am far from denying that morality requires a style of life supposing certain levels of articulateness. But I do wonder whether the dangers of provinciality here aren't very great and especially important in an age such as our own in which confrontations among diverse styles of life are becoming more and more vivid. Part of the protest against "white education"

seems to stem from resentment at attempts to impose the demand for articulateness—white American style—on persons to whose life styles it does violence. And one finds among some student radicals' attempts to identify what bothers them as involving such contrasts as those between reason and intuition, reason and feeling, and justice and compassion—these contrasts being perhaps in part attempts to focus worries about the ramification for styles of life of certain kinds of demands for articulateness.

3. Lastly, how does the law stand here—and particularly on Dworkin's view of law? If part of the alienation of which we are speaking has its source in the middle-class demand for articulateness, and if, on Dworkin's perhaps correct account, law has that demand deeply embedded within it, where are we led? Of what does this show the limits? This question sends us down a long road and one that is difficult to travel. We shall not travel very far down it in the next few minutes.

Revolution Intelligible or Unintelligible*

DAVID BRAYBROOKE

> Perhaps empirical sobriety is so difficult that men will never preserve it except when they are happy. If so, the various irrational faiths of our time are a natural outcome of our self-imposed misfortunes, and a new era of metaphysics may be inspired by new disasters.
>
> Bertrand Russell, *Unpopular Essays.*

My title is ambiguous; my purposes, correspondingly complex. If you put an exclamation mark at the end of the title as it is given, it becomes a demand for action, not minding whether the action is intelligible or not. Put a question mark at the end, and the title becomes a cautionary expression; it suggests that maybe we should make only intelligible revolutions and draw back from unintelligible ones. Left unpunctuated, as I have myself announced it, the title cannot perhaps shake off the burden of the possible punctuations; but left unpunctuated, it serves to introduce a discussion of the different ways in which revolutions may be intelligible or unintelligible. Such a discussion is in fact my chief business, though I mean to treat the question of justifying revolutions simultaneously with the question of understanding them.

Since my discussion will be largely negative in tendency and results, it will certainly offer something that answers to the cautionary interpretation of my title. But I shall not entirely neglect responding to the active interpretation; I cannot see my way to endorsing blind revolutionary action, but not too much should be made of the negative tendency of my discussion. I cannot claim

*More primitive versions of this paper were read at the University of North Carolina at Greensboro in February, 1969, and at a meeting of the inter-university philosophy discussion group at St. Mary's University, Halifax, in March, 1969.

to be a revolutionary; I can claim, speaking as a citizen, to be horrified by certain features of American society and disgusted by others. I am not sure just what has to be done in the end to remove those features, but I can think of a number of initiatives, some of them simply obstructive, that might help; and I do not believe that people who are moved by horror and disgust to take these initiatives can sensibly be asked to refrain until every searching complaint has been given an intelligible place in an up-to-date theory of revolution, which makes good the irrelevant passages in Marxism. We do not need to understand everything about social change to know that some changes would be changes for the better.

The aim of my discussion will be to expose certain confusions to which our thinking about revolution is liable. But I shall not say anything to imply that only confused thinking can lead to the demand for a revolution. My remarks will no more imply this than they will imply that there are only confused ways of thinking about revolution. Once it is seen, for example, that some social changes, proposed in certain forms of words, are really neither intelligible nor justifiable, some people, who thought they wanted a revolution simply because they thought they wanted such changes, may decide that they do not want a revolution after all. They may join the camp of incremental reform instead. Other people (and they may be more perceptive) may continue to desire a revolution; but they, too, may now be more interested in changes for the better that fall short of being a revolution, and they are likely to have a more practical notion now of the revolution that they want. In either case, the people affected by the exposure and clarification that would emerge from a discussion like mine, if it were successful, might aim their efforts at social improvement better—more accurately, at more appropriate targets, with a greater chance of success. Thus there is a perfectly straightforward sense in which I may hope that my remarks will be of as much use to revolutionaries as to more inhibited proponents of reform.

1. There is a great deal of confusion in our current thinking about revolution; and much of this confusion has to do with the

extent to which a revolution is an intelligible process open to reasoned justification (or condemnation). The confusion arises partly because the term "revolution" has been applied to social changes very different in kind and scale, which also differ greatly in intelligibility and justification. But confusion comes also from an independent and probably even more abundant source: Revolution is a subject that is taken up more often than not by excited people, who are inclined to express their revulsion at the present state of things without much care for the exactness of their judgments.

To be exact, their judgments would have to transcend certain fallacies that I believe are common, though they have had no name: The Fallacy of Proportionate Consequences, on the one hand, according to which only big changes can have important consequences; on the other hand is the Fallacy of Easy Changes, according to which small changes are always easier than big ones.[1]

The Fallacy of Easy Changes seduces not revolutionaries, but their opponents; the fallacy that seduces revolutionaries is rather the Fallacy of Proportionate Consequences. It helps to make those who fall victim to it susceptible also to more violent confusions— the Extravagances of Total Change—on which I shall concentrate my attention in this paper. But it is not necessary to commit the fallacy of thinking that only big changes can have important consequences to indulge in the extravagance of thinking that only total change is worth pursuing. Even revolutionaries who rise above the Fallacy of Proportionate Consequences may succumb to such extravagances. The Extravagances of Total Change express —they incite—revolutionary emotions at the highest pitch of excitement and ardor. Furthermore, a number of intellectual features of revolutionary thinking, which I shall try to identify, combine in various ways to make one or another extravagance recurrently plausible, at least to revolutionaries themselves in their moments of excitement.

To treat the Extravagances of Total Change in an expeditious way, I shall construct a composite caricature of revolutionary thought, extracted mainly from Herbert Marcuse, but composite

because it draws also on Jean-Paul Sartre and directly on Karl Marx. I call the construction a caricature, because it cannot be held—by any means—to represent the full thought of any of these writers. I have enough documentation to show that all the features of the caricature do correspond to real tendencies of their thought in some moments, though in at least one direction I deliberately exaggerate the feature to a degree that passes the bounds even of caricature. At best, I could say that the various features of the caricature do belong together, because they lend each other extra strength; and, belonging together, they represent a style of thought to which revolutionaries are often inclined, though perhaps no serious revolutionary thinker ever indulges in the style without restraint, much less continually employs it. But my purpose with the caricature is not so much to represent this style of thought as to place it in a larger interpretive context; I use (and abuse) the caricature as a pretext for surveying the universe of possible interpretations of "total social change," including the most absurd. If a style of thought operates in that universe, then those absurdities are dangers that are liable to beset it.

2. Various extravagances press forward in the following statement by Marcuse:

> I have tried to show that contemporary society is a repressive society in *all* its aspects, that even the comfort, the prosperity, the alleged political and moral freedom are utilized for oppressive ends. I have tried to show that *any* change would require a *total* rejection . . . of this society. And that it is not merely a question of changing the institutions but rather, and this is more important, of *totally* changing human beings in their attitudes, their instincts, their goals, and their values.[2]

Consequently, Marcuse thinks there must be "a *total* break with the content of the needs and aspirations of people as they are conditioned today."[3] How recklessly the universal quantifiers throng together in this demand for total change, one treading on the heels of the one before! This massing of quantifiers convicts the statement of extravagance even if one grants that Marcuse did not intend the extreme of absurdities I am about to describe.

I consider the demand for total change an ill-considered demand. It is not ill-considered because no sense can be made of it, but because making sense of it is so problematical. There are too many senses available. At one extreme, a sense can be given to "total change" that suits the prophetic enthusiasm of Marcuse's statement, but only at the expense of removing any rational grounds for the condemnation that the statement expresses. At the other extreme, the concept of a total social change invites an analysis that leaves lots of room for rational comprehension and justification, but also leaves room for almost every major feature of current society to escape condemnation. Such a sense would clearly not be a suitable vehicle for revolutionary emotions. Some sense between the extremes might mobilize powerful emotions behind a rational case for revolutionary change; but it may be doubted whether those emotions will be as powerful or as gratifying as those let loose at the extreme of extravagant condemnation.

Assume that we find in a given society a set of institutions I_1, $I_2, \ldots I_n$. The examples of institutions that perhaps first come to mind are organizations (the Federal government; the Protestant Episcopal Church; the Army) or types of organizations (the family); but I mean to be speaking broadly enough so that private industry, or the private steel industry, might count as institutions even if they were not considered organizations or types of organizations. I am also ready to include as institutions such things as private property or the common law, which are so far from being organizations that they do not even have members, directly or indirectly. Let us suppose that the set I_1, $I_2, \ldots I_n$ is finite and exhaustive; by this I simply mean that from some point of view it will be accepted as mentioning everything in the society that from that point of view would be recognized as an institution. I do not mean that a complete description of the members of this set would automatically be a complete description of the society. One might reasonably hold that there were many aspects of the society, like harmony or discord between the practices of different institutions, which were not aspects of any one institution;

and others, like the stock of general knowledge, or the distribution of health and happiness among the population, that were not in any simple way aspects even of the institutions taken together. Again, I do not mean to prejudice the possibility of mentioning institutions not in the present set when the society is looked at from a different point of view.

Each of these institutions has a complex of properties p^i_1, p^i_2, ... p^i_n, which to some extent may be shared by different institutions. It is convenient for purposes of theory to divide the properties of any given institution into two classes: the properties of embracing certain norms or social rules as against other properties like age, location, and number of people involved. To define an institution, some subset of its norm-properties would be used; to explicate its character, further norm-properties would be chiefly, perhaps solely, relied upon. Thus the family in our society may be defined by citing norms that permit men and women to pair off permanently and that oblige them (with certain exceptions) to live together once paired and provide for their children; the character of the family would be further explicated by citing norms about discipline, private property, relations with grandchildren, etc. I shall *not* assume that the list of properties, or of norm-properties, to be ascribed to any given institution is finite; but the possibly infinite sets here may present no real difficulty, for most of the content of the most characteristic norms—enough to infer fairly accurately any part of the rest—can perhaps be conveyed (in various ways) in finite accounts.

2.1. What shall we understand by a total change in the society all of whose institutions make up the given set I_1, I_2 ... I_n? Evidently those institutions, along with much else, must change; and it may be suggested—working at one extreme of the range of senses for "total change"—that they must all change in a thorough-going way. Thorough-going within certain limits: There are, though I shall give no great weight to them, some properties of the given institutions that cannot sensibly be supposed to be changed. Given that there will be a society of some sort after the change, its institutions will inevitably share some properties with

the institutions of the present one, for example, the property of being preceded by the same institutions as preceded the present institutions; and the property of being located, if not in the same region of the same continent, at least in the same material universe.

Grant the persistence of such properties; there is still a great deal of room left for change. To make as much use of that room as possible, which "total change" insists upon and that this extreme of its range would require, one might assert among other things that every norm-property of every one of those institutions $I_1, I_2, \ldots I_n$ would have to change into its opposite—from p^i_k into $\sim p^i_k$,—which may be more or less determinate as some other property Q^i_k. If in the present institution of the family, there is a rule obliging parents to provide for their children, that rule must be changed to its opposite, which is determinately a rule permitting them to forbear from making such provisions. A rule permitting wives to go out to work would have to be superseded by a rule obliging them to stay at home (which suggests that some of the logically required features of a total change might turn out to be ironically reactionary).[4]

However, these changes in norm-properties—in all the norm-properties of all the given institutions—fall far short of being thorough-going changes in the institutions. Something recognizably like present institutions might survive even if all the norm-properties were changed to their opposites. Would there not, for example, still be the institution of the family, manifested in many particular households where parents and children lived together? The parents would now be permitted to forbear from providing for the children, but they would not be obliged to forbear; and now that wives were obliged to stay at home, the provisions might in some cases be more detailed than before. In short, the family (with its multiple manifestations) would survive as a locus of norms; and changing the norms for their opposites would not necessarily make it a very different institution in daily practice.

For a total change—within the space we have allowed for change—evidently more must be demanded than changing all the norm-properties to their opposites. I think one must say, besides,

that the institutions must be abolished; not one of them must survive even as a locus of norms; there must be no institution after the change that uniquely corresponds to any of the present institutions. A weaker condition would leave some points of resemblance that could (logically) be eliminated. So far as the family goes, some provision would have to be made for procreation; but it is already possible to make such provisions without even bringing biological fathers (donors of sperm) and biological mothers together; and once born, children can be brought up wholly apart from their mothers.

Even now the total change that is at issue is not as total as it might be; for it is limited as regards institutions, to changing the properties of the set of institutions discovered on only one approach to categorizing the institutions of the society in question. But other approaches may discover other institutions in the same society. For example, some students of American society do not find it to be stratified into social classes,[5] while many others notoriously do.[6] Very likely the difference is one to be settled by a correct assessment of the empirical evidence;[7] but it is just possible that some approach to categorizing American institutions which discovers the institution (or institutions) of social classes and some approach which does not are equally well-founded alternatives. To make total change as total as possible, we must stipulate that all the institutions discovered on all the well-founded alternative approaches to categorizing institutions are to be abolished.

One sense of "total change" in a society—a sense to be found at that extreme of the range of possible senses at which maximum force is given to "total"—is now in view. It seems almost certain that no one could understand enough beforehand about any such change to justify undertaking it, whatever aims it was desired to achieve.

I suppose it is just possible to imagine changing from present institutions with their present properties to institutions with properties known from the past or met with in other contemporary cultures; such changes might mount up to a total change in the present

sense; and just possibly—barely possibly—enough might be known about the resulting properties to be able to predict how they would work out together. Ironically, the most likely way of ensuring that there would be enough knowledge to make these predictions would be to change back to some former culture, if a sufficiently different one could be found, or to some very primitive contemporary culture. Obviously, Russian society nowadays is not different enough; nor is Chinese society, or Cuban. Sparta, or the Ottoman Empire under Suleiman the Magnificent, or the Bushmen of the Kalahari Desert are somewhat more promising possibilities; but I doubt whether even these would work.

In fact, if the change is going to be total in the present sense, then, whatever known properties it brings in from the past or from other cultures, it is almost surely going to also bring in so many unknown properties and so many unknown institutions, assorted in such unprecedented ways, that most of our present social science will be useless. For outside anthropology (and perhaps linguistics), most of our present social science—our economics, political science, and sociology—is founded upon knowledge of the norm-properties of our present institutions.

There are no doubt some general laws about the dependence of any institutions on provisions for communication, control, and the exchange of services for reinforcements. We could predict that even after a total change there would be no successful institutions which offended against the necessary conditions imposed by these laws. But whether there will be any successful institutions after the change, or how soon they will appear, are questions that are likely beforehand to be left in hopeless uncertainty; and none of the laws or attempts at laws in the antecedents of which there is an essential reference to the character of any of our present institutions will apply to the institutions that it is proposed to experiment with (should any of these be specified).

In such laws or attempts at laws, we either predict that people will behave toward one another in certain ways because they are conforming to the norms discovered in those institutions; or that,

given the norms they happen to conform to, certain sorts of be-
havior will be reinforced positively and certain sorts will not be
(or will be reinforced negatively). The relation between work per-
formance and wage rates, for example, is subject to both sorts of
predictions. Even the features of our society, like the incidence of
various diseases, that might seem most remote from human conven-
tions are affected in important ways by the norm-properties of pres-
ent institutions; for norms govern diets and various practices as-
sisting or obstructing the communication of diseases. It is true that
knowledge of the effects of one norm-property often involves as a
logical consequence some knowledge of the effects of its opposite
(the diet case serves again as an example); but the help that this
sort of connection might afford in predicting the effects of the new
institutions will be largely defeated by the stipulation that none of
the new institutions will uniquely correspond to any of the present
ones.

I have perhaps allowed too much room for the application of our
present knowledge to a total change, even in arguing that it would
probably not be enough knowledge to understand the change that
was called for. Our present knowledge is an aspect of our present
society; its content helps account for the character of the institu-
tions that apply it, preserve it, extend it, and transmit it. Would
not a total change sweep away all our present knowledge, includ-
ing our knowledge of past institutions and other cultures? Then a
total change (at this extreme of the range of senses) would be
totally unintelligible, except that we would know everything must
be different in ways that we could not predict.

Even if some of our present knowledge does remain useful, how-
ever, evidently a total change will not be something that can easily
be justified to us beforehand. Marcuse, remember, calls for "totally
changing human beings in their attitudes, their instincts, their
goals, and their values."[8] Maybe a total change covering these
points would not be incompatible with our being acquainted with
values held by other people in the past or in other cultures; but
how relevant would such values be to justification now? It is hard
to see just how values that we ourselves now cherish could be in-

voked to justify a total change after which those values would all
be rejected. Even if we valued change for its own sake, would we
approve of a change one consequence of which would be that
thenceforth no one would value change? But we do not value change
for its own sake; we do not welcome changes that appear to worsen
our lot or that of our posterity.

Possibly our values would be rejected after a certain change, yet
nevertheless would, paradoxically, be more fully realized than they
are now. Then the change could be justified to us. But I know of no
attempt, successful or unsuccessful, to argue that we are in the very
paradoxical situation of confronting such a change. The justifica-
tions, or attempted justifications, that I know of all rely on some
values cherished now—and as it happens, not only by revolution-
aries—which are expected to continue to be values after the change
at issue: bread, peace, freedom, health, happiness, human dignity,
justice. One might well wonder whether the persistence of such
values may not require the persistence at least in part of some of the
institutions in which we have become familiar with them. Is there,
for example, going to be justice without anything like courts and
rights and the law as we know them?

Sartre's true revolutionary, more of an extremist than Marcuse on
this point, nevertheless affects to repudiate values as such, along
with mere bourgeois values. According to Sartre, who sympathizes
with this move although he does not endorse it, the true revolu-
tionary even refuses to say that he is aiming at a better way of or-
ganizing the human community. The true revolutionary adopts
this position, Sartre says, because he "fears that a return to values
. . . would open the door to new mystifications."[9] And might not
a total change involve just this extremism on the point of values?
Attempting to justify actions by invoking shared values is after all
a characteristic practice of present society; it would, of course, have
to disappear in a total change, and thinkers who looked forward
to its disappearance might have no patience with its present uses.

It seems clear that if a total social change, in the sense under
consideration, is not by definition both wholly unintelligible and
unjustifiable beforehand, it is (waiving a most unlikely set of spe-

cial assumptions) surely going to be unintelligible to such an extent and so difficult to justify that hardly anyone would seriously call for it. Even from the point of view of a determined revolutionary, calling for a total social change, in this sense, must be accounted as an extravagance of rhetoric and emotion: tactically useful, perhaps; perhaps emotionally gratifying; but still an extravagance.

2.11. Let us try for a sense at the other, less extravagant end of the range of possible senses for "total change." Suppose we say that by a "total change" in a society we shall mean that in every institution discovered on a given approach to categorizing and analyzing the institutions of that society some norm-property or other changes. There are very likely many quite familiar proposals for social reform that would lead to total changes in this sense. For example, relieving the police of traffic duties might conceivably lead to a change in at least one of the norm-properties of every other institution. In the family, in the church, and elsewhere, people might with distinctly less than the currently tolerated qualifications be called upon to act on the principle that it is never a matter of indifference to break a law or evade police action.

Total change in this sense does not need much discussion. The trouble with it, from a revolutionary's point of view, is that it may well be too modest a change to excite revolutionary emotion and ardor. Relieving the police of traffic duties, with the consequences cited, might be a very good thing; the consequences, and therefore the change, might even be considered important. But no one is going to pledge his life, his fortune, and his sacred honor to bring such a change about.

The same uncongenial possibility—of being too modest to be exciting—afflicts an alternative sense in which a "total change" would be taken to mean one in which every norm-property discovered in every institution changed. This sort of change sounds very sweeping because of the number of properties involved. But the changes in all those properties might be quite trivial ones, so that the total change would after all be quite modest. Imagine, for example, that to formulate any of the norms discoverable in a given society, one would have to mention as a condition of its application

either that the persons it applied to were twenty-one years old or older, twenty-one being the age of majority, or that they were younger. If the age of majority was lowered to twenty and one-half every norm discoverable in the society would have to be adjusted accordingly; but again the changes would hardly be exciting.

2.2. When revolutionaries call for total change, shall they then be understood to mean something between the extremes just mentioned? I expect that when they are ready to speak soberly, they would settle for a big change, perhaps a change in a number of leading properties in every institution discovered on some given approach to categorizing institutions, in which case "total" would still, through the survival of at least one universal quantifier, have a slender claim to being taken literally. They might even settle for having most of the leading institutions change in important ways. Then "total" would have to be excused as hyperbole. But by way of excuse, revolutionaries might say, quite plausibly, that no one could tell beforehand how far the changes which they regarded as essential would reverberate through any whole set of institutions; moreover, to make those changes good very likely changes would have to be made throughout the set; and for their part they wished to insist that these other changes be made, too, as necessary, and wished to indicate that they were prepared to endorse far-reaching reverberations.

By settling for something less than total change at its most extravagant, revolutionaries in sober moods improve their chances of being able to predict and explain the effects of the changes which they demand. They further assist their cause intellectually by retaining an impressive selection of present values, which can be invoked to justify and motivate the changes. The dialectics of Marx and his followers has exploited both these advantages: understanding founded on the persistence of some present institutions; justification founded on the persistence of some present values. The main effort of dialectical argument has not been directed at society as a whole, but against one constellation of institutions and norm-properties (which is due, or overdue, to disintegrate) in favor of another constellation (which is currently amassing the strength to

become dominant in its turn). Revolutionary thinkers like Marcuse are inclined, when speaking loosely, to identify "present society" with the constellation of institutions and norm-properties now dominant. A "total change" in "present society," so understood, would fit into the range of senses that we have discussed at an intermediate position, if it fit into the range at all, and it would be no more sweeping than a change in such an intermediate sense.

Marxist dialectics has traditionally been inclined to identify the rising constellation with the institutions which the working class develops as it awakens to revolutionary class consciousness. The values on which the solidarity of the working class is founded justify the revolution; and the practice which the working class gains in institutionalizing those values foreshadows the nature and effects of characteristic institutions in the society that will follow the revolution. This approach to the values and institutions of the working class may seem naively romantic. Attempts by dialectical thinkers to adapt to their disillusionment with the working class by discovering the lineaments of a future society in the values and revolutionary institutions of university students or of a new revolutionary class in which university students will be joined by other oppressed people[10] may seem more romantic still. But our discussion indicates that these notions are not merely romantic; they answer to the important intellectual requirement that the revolution be intelligible and justifiable so far as possible by some selection of terms from present experience, present knowledge, present values. Dialectical thinkers, both Marxist and post-Marxist, may be fairly said not only to have learned (or anticipated) the lesson that to make sense of the demand for social change they must pick some institutions and some values to favor. They may also be said to have tried to go beyond this lesson in identifying some working combination of institutions and values as a model of the new society.

2.3. Whether revolutionary thought succeeds on these other lines is something that I shall not try to determine; I shall have to content myself in this paper with showing that the chances of success are likely to be greatly improved if the Extravagances of Total Change are avoided. I have not yet finished with these Extrava-

gances. Whether revolutionary thinkers avoid them depends on their being ready to think soberly and patiently about social change; and I do not believe that all of them are ready to think or speak soberly and patiently all the time. I do not believe that Marcuse and Sartre are; even Marx, whose patience in thinking about the subject could hardly be excelled, had moments of unsober thought.

There are, I believe, three predispositions that incline revolutionary thinkers belonging at least loosely to the Marxist tradition (Marx himself, and Marcuse and Sartre as well) to permit themselves, in some moods, some of the time, expressions that come close to inviting interpretation at the extravagant extreme of senses of "total change," in the range of senses I have considered. Literally interpreted, the expressions demand some such sense; figuratively interpreted, recognized as vehicles for emotive meaning, they trade upon an indeterminately large proportion of the literal sense. The three predispositions that have this effect within the range of senses already considered also combine to encourage the use of "total change" in quite a different sense, which leads to extravagances of its own.

The first of these predispositions I have already alluded to several times; it is the emotional predisposition to total denunciation. The emotions that at least in some moods revolutionary thinkers feel—even rejoice in feeling—are too powerful to be checked by distinctions and qualifications. Hence in these moods revolutionaries are not going to be content with any of the intermediate senses in the range of "total change"; they are going to express themselves in terms that point toward the extreme of extravagance. I think there is more than a little self-indulgence in the expression of these emotions; but it would not be fair to suggest that there was no more than self-indulgence. Chief among the emotions felt, and the source of the rest, might be genuine horror at the iniquities of present institutions; there are plenty of genuine iniquities to provoke the horror.

The emotions of total denunciation have, moreover, something like an intellectual justification in the second of the predispositions to speak and think of "total change" in extravagant terms. This

second predisposition is one that inclines revolutionary thinkers to look for ways of comprehending history as a whole. Unless history "adds up," Sartre says, it is meaningless.[11] A true revolutionary needs a "total" philosophy, which will give him a "total clarification of the human condition"; and action by the revolutionary—one presumes, a fortiori, the revolution to which his action is meant to contribute—"has significance only if it brings into question the fate of mankind."[12]

I sympathize with the second predisposition and its demands up to a point. It would be very exciting to have a way of understanding history in which everything added up, or at least everything important in the mainstream of history (cf. Hegel). I suppose that means having the unity of a single story with an appropriate dramatic dénouement, foreshadowed to the point of being logically inevitable. To heighten the drama, the inevitability had best be problematic until almost the last moment, and the dénouement should in effect solve some long-standing philosophical issue of the greatest importance, like the purpose of creation, the meaning of life, the discrepancy between subject and object, or the secret of social harmony. If there were a true story of this kind to tell about history, it would not only be exciting to know it; it would be humiliating not to know it. Not knowing it, we would miss the very point of history.

But is there any true story of this kind? Merely wishing for a true story will not call it into being. One can perhaps tell a unified story of a man's progress in technological capacity and in the organization of science; but such a story would probably not exhibit a central conflict or climax in one dramatic denouement. It would not satisfy Sartre and other revolutionaries. To add up in their eyes, history must be shown to resolve some comprehensive conflict, which affects everything in human life and society, like the conflict that Hegel alleged had continued since the breakdown of the Greek city-state between reason and institutional reality. "In a perfect . . . commonwealth . . . the unity of reason and reality will be brought about"; then "each individual" will have "realized his human essence as a common socio-political existence."[13]

Typically, the demand for a story that adds everything up goes beyond these prosaic formulas in which Löwith paraphrases some dicta shared by Hegel and Marx. A story is demanded that will herald the salvation of mankind from long duress in his state of evil. Raised this high, the demand reflects the third predisposition that I ascribe to revolutionary thinkers in the tradition of Marx—the predisposition to approach the question of social change in the spirit of religious prophecy.

I am sure Marcuse and Sartre would not relish this ascription; they certainly do not conceive of themselves as religious thinkers (though very likely they would admit to much more concern with religion than most English-speaking philosophers). But nor did Marx conceive of himself as a religious thinker; and I think the case that Marx's thought exhibited the spirit of religious prophecy is conclusive. His thought was cast in a religious pattern; it exhibited a spirit consonant with that pattern. As Löwith has shown (in *Meaning in History*, in a short chapter which I consider the most brilliant and illuminating comment on Marxism ever written), Marx's thought was cast, moreover, in the exact pattern of Judaeo-Christian eschatology. Marx cannot abide the society about him, its iniquities corrupt it through and through; he condemns the corruption by a standard of absolute righteousness;[14] he looks forward to the world to come, which is to be ushered in by the redemptive mission of that saving remnant, the proletariat of advanced industrial society: "*Only* the proletarians who are *completely* excluded from *all* spontaneous exercise of their human faculties are also capable of achieving a *complete* . . . emancipation by the appropriation of the *totality* of *all* means of production."[15] The universal quantifiers throng together as closely in that passage as in the passage I quoted earlier from Marcuse, with equal disregard for sober claims on justifying evidence.

It is easy to see how prophetic reactions to the corruption of present society might sweep past the point at which dialectics draws a distinction in favor of the proletariat while it condemns the ruling class and its constellation of institutions. A religious thinker typically believes himself to have been corrupted too; in a sinful

society, no one can account himself free from sin. "We have erred, and strayed from Thy ways like lost sheep. . . . And there is *no* health in us."[16] Surely many Americans, reflecting on the iniquities of the Vietnam War and of the treatment accorded poor people and black people at home, have felt simultaneously responsible; powerless; ashamed. Small attempts at reform, which may have enlisted their part-time efforts as well as their part-time sympathy, do not seem to have worked; seemingly, no improvements can be brought about unless the whole set-up is changed—which may be true, in the sense that probably a very sweeping change is necessary, which might in the end lead to a "total change" in some sense short of extravagance. Shame and despair may, however, take people past that point, to the point of being ready to entertain proposals of total change, without making sure that they are not proposals tending toward the extreme of extravagance. Even when brought this far, people might still be restrained, by other sentiments, by lingering commitments to the present dominant constellation of institutions, from adopting any such proposal; similarly, actual revolutionaries might be restrained by the presence of what they regard as the rising constellation and by their commitments to it. Emotions, a desire to have history add up, and prophetic thinking will, however, from time to time, drive both groups—actual revolutionaries and a potential audience of conscientious people less revolutionary in initial inclination—through the range towards the extreme of extravagance.

2.4. The three predispositions also encourage revolutionaries to think and speak of "total change" in quite a different sense, which does not belong to the range discussed earlier. We can speak of a "total change" in a man's condition or circumstances, when, for example, he inherits a fortune, having been penniless; or, having been sentenced to hang, he receives a pardon. May we not speak similarly of a "total change" in the condition of a society if from being in one condition it changes into being in the opposite condition? To excite any interest on the part of revolutionaries, the condition must be an important one. Otherwise any novelty could be

called a "total change": if the post office stops delivering mail on Saturdays, the former condition that society was in, of receiving mail on Saturdays, has been changed to its opposite. To rule such changes out—indeed, to preserve the analogy with "total changes" in the conditions or circumstances of single persons—it must be recognized that a "total" social change in this sense is a change in some important condition affecting the whole society; and to do full justice to revolutionary thought in this connection, we must say, not merely "important," but "supremely important."

This sense of "total change" does not license any of the extravagances found in the range of senses discussed earlier. There what was at issue, in accordance with the quotation from Marcuse, was a "total change" in the society (compare a "total change" in the condemned prisoner); here we have to do with a total change in a condition, in perhaps just one, or more than one of the features of the society in question, without any claim as to change in them all. Nevertheless, I expect the two senses often are confused, and that because of the confusion, people are led from thinking of a total change in a condition to calling extravagantly for a total change in society. Likeness in phrasing promotes the confusion; consider especially the equivocal phrase, "a total change in the [not "a"] condition of society." Convergence in emotions also contributes; a total change in a supremely important condition may generate as much emotion, and it may be as unrestrained, as any of the emotions operating over the range of other senses.

For through variations in the conception of a supremely important condition this sense of "total change" is subject to extravagances of its own. Very often the supremely important condition that revolutionary thinkers have in mind seems to be what I shall call a condition of metaphysical evil. A metaphysical evil is one that mankind the world over can be said to be afflicted with, regardless of any statistical evidence about the health of individual men, about their feelings, or about their freedom and their chances of giving sustained expression to their talents. Religious thinking offers the leading examples of metaphysical evil; I might as well,

or better, have spoken of theological evil. The condition of sin is, of course, the central example; it is to be totally changed by salvation, the return to grace. But there are many variations on this theme. Kierkegaard holds that everyone is sick with sin and in despair.[17] He has no need to collect any evidence, since he divides up all mankind a priori into those who consciously feel despair and those who do not; and then argues that unconsciousness of despair is the worst and most perfect form of despair.[18]

Are not some further variations to be found in the thinking of revolutionaries? "Alienation" (which recalls the alienation of man from God); "exploitation"; "repression"; "domination"; these are all conceptions of the supremely important condition which revolution is to totally change, and I think they are all used by revolutionary thinkers, some of the time, with no better backing than conditions of metaphysical evil. Marx's theory of exploitation, for example, follows directly from his labor theory of value; and in Volume III of *Capital*, confronting at last some of the evidence that upsets the labor theory of value as an empirical hypothesis, Marx converted it into a truth by definition, detaching exploitation, too, from empirical evidence. Is not the "freedom" which is to be found on the other side of the change liable to be a metaphysical freedom? Religious thinkers have promised "freedom," too—freedom from the bondage of sin.

Notions of metaphysical evil are, I think, very dangerous notions; and I mean dangerous, not just mistaken, and liable to lead to further mistakes. They lead revolutionaries, like prophets, to write off carelessly the people, possibly a very large number, who are reasonably happy and healthy and busy, according to their talents, doing valuable things in our present society. If these people are even mentioned, it is only to suggest that their happiness is false happiness; their productions are without true value; their health is only apparent or undeserved.[19] Notions of metaphysical evil thus blind men to the damage that a given social change may do. They blind men further by arousing dangerously extravagant emotions. The emptiness under analysis of notions of metaphysical evil un-

fortunately does not prevent them from giving color to the most sweeping denunciations.

There are, of course, non-metaphysical ways of conceiving of the supremely important condition. The supremely important condition, which was to be changed, might be thought supremely important because of its far-reaching adverse effects on human welfare, in which I include happiness. Such a condition would rightly arouse powerful emotions of indignation; but the relevance of such emotions to the condition, or to any proposed change in it, would depend upon statistical evidence about the distribution of health and happiness and other ingredients of welfare before and after the change. To his credit, Marcuse, in a sober mood, fully recognizes as much. In this mood, he acknowledges that a revolution can be justified only if it serves "to establish, to promote or to extend human freedom and happiness in a commonwealth, regardless of the form of government."[20] Furthermore, to carry out such a justification, Marcuse recognizes, it is necessary to undertake a "calculus" in which the advantages and disadvantages of the institutions on both sides of the change are weighed.[21] A social change—a total change in the condition of society—will be justified only if *on balance* it contributes to freedom and happiness. I think that the very least which we might ask of revolutionaries is that if they are going to pick out supremely important conditions, they pick out conditions that admit of changes motivated by such evidence. We might ask more: it is not clear to me that we would be justified in making a number of people who are happy now unhappy simply in order to make a greater number happy who are unhappy now, unless (as Marcuse inclines to claim)[22] we are compelled to choose. But then the fact of compulsion must be proved, which will entail proving that compromise policies are not feasible.

3. I have claimed that my remarks, though mainly negative in tendency, might be as much help to revolutionaries as to non-revolutionaries. I think it is helpful to show that some targets, though exciting in conception, are illusory or irrelevant or otherwise counterindicated; that is a negative showing, but it encour-

ages people to look for more suitable targets, to choose them with more care, perhaps to aim at them more steadily. I have also done something, though not at very great length, to indicate positively how the search for suitable targets might be conducted if it is to be conducted soberly; and it is noteworthy that both in my references to dialectics and in my reference to a calculus of advantages I have been able to draw upon revolutionary thinkers for guidance in this connection.

Moreover, as a practical consequence of logically closing off certain unprofitable lines of thought, the attention of people interested in the subject of revolution may be deflected by arguments like mine to specific points that need remedying in our society—targets themselves, or reasons for finding specific institutions relevant targets. I have in mind, for example, the many valuable points that Marcuse has made, with searching insight, about the commercial distortion of our needs and tastes; the excessive sacrifices exacted from us in the way of life-consuming discipline and work; the dangerous and irrational predominance of military considerations and the arms industry; the carelessly absorbent permissiveness with which dissent is received and rendered ineffectual.

However, one trouble with negative remarks and sober alternatives is that they are all too commonly put forward with the intention, more or less conscious, more or less disingenuous, of delaying and frustrating effective revolutionary action. I am, as I said, not a revolutionary in temperament; I am a comfortably fixed upper-middle-class professor with a family to maintain, so I am very far from being a revolutionary by circumstances. Though I was once quite active politically (part-time), I am not very active at the moment; since I choose to live in another country, in an anachronistically quiet, small-scale environment at the very periphery of the continent, I might well be judged a political dropout, except perhaps for what I say or write. Can I be trusted to be objective on the subject of revolution? Can I trust myself?

If I point out, for example, that though Marcuse has acknowledged the need for a calculus of advantages, I do not believe there is any instance in which he has actually had the patience to carry it out,

I shall seem (once more) to be trying to discredit Marcuse; more important, I shall seem to be implying that if the sober alternative of proceeding by a calculus of advantages is taken, action must be indefinitely delayed until more information has been collected, analyzed, and fully debated. We should appoint a committee, which in time will report on the question whether a revolution should be considered as a possible item for a later agenda.

Such delaying tactics do not, however, follow from my discussion, whatever suspicion may attach to my motives. There may be features of our present society so obviously adverse to human welfare as to invite attack without further ado. As it happens, I agree with Marcuse and Sartre that there are such features; I agree, more with Marcuse than with Sartre, on what those features are. I sympathize with Oglesby's feeling that it is better to act against such targets without waiting for a relevant contemporary theory of revolution than not to act at all.[23] I concede a good deal to the contention of Sartre and others that a revolutionary may have to learn what a revolution is about step-by-step in the actual course of conducting one.[24] It is not irrational to begin attacking institutions without knowing how big a change will have to be put through to remove the evils due to them.

There are many evil features of our present society. They cluster institutionally into a great number of suitable targets. If action is to be taken against all of them, however, is it not likely to be ineffectual if it is not guided by some general idea of comprehensive social change and coordinated by a revolutionary movement united behind that idea? I do not know the answer to that question; I can suggest that at this moment in history there happens to be an alternative way of proceeding.

There are also a very great number of people, very diverse in the talents that they could bring to the cause, and so heterogeneous in political outlook as to range from the far left to the far right, who are willing to act against various evils which all agree to be such, chiefly, the military-industrial complex and its terrifying adventures at home and abroad. Without ceasing to act against other targets

on which there is not so much agreement, could we not make this, on which there is, our main priority? We perhaps need not act in unison; it may suffice to act in parallel. We need not act in the same way; let everyone do the thing that he can do most effectively. We need not adopt the same ultimate goals, so long as we act in the same direction. In particular, we need not commit ourselves beforehand to a change of any fixed dimension. The rational principle to apply in this connection would have us each resolve to go on acting until our actions ceased to effect a net reduction in evil. Different members of the anti-militarist front will no doubt disagree as to when this margin has been reached; but maybe no important disagreements will occur before substantial successes have been achieved; and maybe enough agreement will persist long enough to achieve a change so big as to deserve being called revolutionary.

NOTES

1. These fallacies look very simple-minded. I think that they nevertheless deserve extended analysis, not only because of their widespread operation, but also because the temptations that lead to them are surprisingly subtle and insidious. The temptations have to do, for instance, with overlapping criteria for the "bigness" and "importance" of social changes; with the identity (if I may so speak) of the change under discussion and the (dubious) supposition that it is susceptible of narrower or wider descriptions; with the question-begging choice of other changes that happen to be bigger and more difficult as relevant objects of comparison.

2. *New York Times Magazine* (October 27, 1968), p. 29; my emphasis.

3. Ibid., p. 30; again my emphasis. Is it fair to put as much weight as I am going to put on views a man expresses in a newspaper interview, even views purporting to be directly quoted from him? I expect it is not entirely fair; but I use the passage not so much to score points against Marcuse (who, I recognize, and shall repeatedly acknowledge, has much else to say) as to show that the Extravagances of Total Change have some currency. I might note that *The New York Times Index* through December 1968 mentions no correction offered by Marcuse to the interview as reported, including the statements I cite from it.

4. I am taking the opposite of the property of having a certain norm to be the property of having the negation-norm (the contradictory) of that

norm, in accordance with the discussion by G. H. von Wright, in *Norm and Action* (London, 1963), pp. 139–40. If we suppose that the present rule is a permission for wives either to go out to work or to forbear doing so, it will have to be regarded as tautologous and it will have no self-consistent negation-norm (*op. cit.*, pp. 153–54). For such two-way permissions, one might go beyond von Wright and stipulate that the opposite norm-property would be either the property of having a norm obliging the doing or the property of having a norm obliging the forbearing, but not both. For example, after the change, either wives would be obliged to go out to work or they would be obliged to stay at home. My argument from this point on would be unaffected, though the indeterminateness of the opposite indicates how far from being entirely clear even the apparently simple notion of changing a single norm-property happens to be.

5. Cf. Roger Brown, *Social Psychology* (New York, 1965), pp. 113–35.

6. E.g., authors referred to by Brown, and innumerable Marxist writers.

7. Which is what Brown himself argues.

8. Loc. cit.

9. J.-P. Sartre, "Matérialisme et révolution," in *Situations*, III (Paris, 1949), p. 193.

10. Cf. Carl Oglesby, "The Idea of the New Left," *Evergreen Review* XIII:63 (February, 1969), pp. 51–54, 83–88, especially p. 87.

11. J.-P. Sartre, *Critique de la raison dialectique* (Paris, 1960), p. 10.

12. "Matérialisme et révolution," p. 180.

13. Cited by Karl Löwith, *Meaning in History* (Chicago, 1949), p. 50.

14. "Amos, what do you see?" "A plumb-line," I replied. The Eternal said, "With a plumb-line I test my people; never again will I pardon them." *The Bible*, Amos 7: 8 (Moffatt translation).

15. Quoted by Löwith, pp. 37–38; my emphasis.

16. *Book of Common Prayer*, A General Confession; my emphasis.

17. S. Kierkegaard, *The Sickness Unto Death*, tr. Walter Lowrie (Princeton, 1941), p. 32.

18. Ibid., pp. 69–71.

19. Cf. H. Marcuse, *Eros and Civilization* (New York, 1961), pp. 42, 89–91, 94.

20. "Ethics and Revolution," in R. T. De George, ed., *Ethics and Society* (New York, 1966), pp. 133–47, at p. 133. It is only fair to acknowledge that Amos, too, was very much concerned with statistical considerations bearing upon social justice.

21. I take it that Marcus is using "calculus," not to refer narrowly to a calculus of the sort Bentham projected, but broadly enough to include what I have elsewhere discussed as censuses (e.g., in C. E. Lindblom's and my

book, *A Strategy of Decision*: *Policy Evaluation as a Social Process* [New York, 1963], Chap. 8; and in my book, *Three Tests for Democracy*: *Personal Rights; Human Welfare; Collective Preference* [New York, 1968], Part Two, Sec. 2).

22. Ibid., p. 145.
23. "The Idea of the New Left," p. 86.
24. "Matérialisme et révolution," p. 184.

Comments

MARSHALL COHEN

I doubt whether any historically significant revolutionary thinker can be interpreted as proposing Total Change in the Extravagant Senses that Professor Braybrooke undertakes to examine in the main section of his paper. I therefore regard this part of his paper as an exercise in Heraclitean metaphysics, interesting in its own right, but of questionable relevance to the writers who inspire his discussion. This can be seen by considering not only the third and most extreme requirement that he develops (according to which "all institutions discovered on all the well-founded alternative approaches to categorizing institutions are to be abolished") but even by considering the second and more moderate requirement (according to which all institutions defined by *some* well-founded approach to categorizing institutions must be abolished).

We may consider, in this connection, his own example of the family, for it is, of course, an institution to which revolutionary thinkers have devoted considerable attention. Marx, for instance, in his scornful—and witty—comments on the nature and hypocrisy of the bourgeois family in *The Communist Manifesto* does not suggest that the family will be abolished in the communist future, but only that it will undergo radical change.[1] Wives will no longer be treated as mere instruments of production, or children as articles of commerce and instruments of labor. (It is because the bourgeois sees his wife as an instrument of production that he believes the common ownership of production implies the common ownership of wives.) On the contrary, "large-scale industry by assigning, as it does, an important part in the process of production, outside the domestic sphere, to women, to young persons, to children of both sexes, creates a new economic basis for a higher *form* of the family

and the relations between the sexes. "It is" he says, "just as absurd to regard the Teutonic-Christian form of family as absolute as it would be to apply that character to the ancient Roman, the ancient Greek, or the Eastern forms. . . ."[2]

So, Marx does not believe that all institutions (on all, or even on the presently received, categorizations) must be abolished for he does not believe that the family, but only a particular form of it, must be abolished. He is perfectly willing to allow the existence of this (and of other) institutions that "uniquely correspond" to existing institutions and which Braybrooke's second criterion is designed to rule out. (It is not true, incidentally, as Braybrooke says, that this uniquely corresponding institution, the post-bourgeois family, requires a sense of total change stronger than the first sense if it is to be ruled out. At least this is not so if I correctly understand his notion of norm-properties and his method of individuating institutions.) He thinks he needs this stronger requirement because, in his example, he seems to imagine that only inessential norm-properties will be transformed into their opposites. But he neglects the fact that if all norm-properties are transformed into their opposites the essential ones will be too. If, in his own example, and on what I take to be his view, the norm requiring the cohabitation of parents and children (and other norms of a similar status) are negated the institution of the family as he conceives it would not in fact survive. His first criterion is quite strong enough to do the work for which he has designed the second while still being too strong to formulate the kind of change that Marx actually required of institutions like the family. But this would not have surprised Marx, who thought it characteristic of the bourgeoisie to believe that when communists demand the abolition of private property they demand the abolition of property itself, when they attack class culture they attack culture itself, and that when they anticipate the abolition of the bourgeois family they anticipate the abolition of the family itself.

Of course, I do not wish to suggest that Marx did not think that certain institutions, even certain central and abstractly character-

ized institutions, would be abolished by the coming revolution. In some cases he did, in some he didn't, and about some cases he was either unclear or actually self-contradictory. On the crucial question of the future status of labor it is quite unclear whether he supposed that the overthrow of capitalism and the liberation of the proletarian *Knecht* from the capitalistic *Herr* would put an end to alienated labor or to labor itself. (The point is of particular importance as he seems, at times, to have defined man as *animal laborans*.)[3] But, if Marx was unclear on this point he did seem to believe that the revolution (anticipated in this respect by the Paris Commune) would bring an end to politics (by repossessing the social power now alienated in the state). "The working class in the course of its development will substitute for the old civil society [Hegel's *bürgerliche Gesellschaft*] an association which will exclude classes and their antagonism and there will no longer be any political power, properly so-called, since political power is precisely the official expression of the antagonisms of civil society."[4] The government of men will be superseded by the administration of things.[5]

In his substantive positions Marcuse is often more utopian and radical than Marx and this is one of the reasons why he is more given than Marx to the kind of language that Braybrooke deplores. For instance, while Marx thinks that the development of large-scale industry will allow the family to assume a higher form, Marcuse thinks that the productive capacities already implicit in capitalism, in particular automation, will make physical labor virtually unnecessary, and thereby permit the abolition of the very institution of the family. For the family is simply a form imposed upon the libido by the requirements of the reality principle, by society's need to secure and organize labor. Society forbids the perversions and institutionalizes procreation in order to guarantee a labor force; it desexualizes the body and encourages genital primacy in order to transform the rest of the body into an instrument of labor. Marcuse believes that, like the surplus value the capitalist system appropriates, the surplus repression it enforces is a dispens-

able feature of present social arrangements. (Freud's fundamental mistake was to take the "performance" principle of existing society for the "reality" principle itself.) In the era of automation the economic system will no longer require a division of labor—and neither will the body. Work will give way to play and genital sexuality to polymorphously perverse eroticism. The organism, no longer an instrument of alienated labor, will be the subject of self-realization.[6] When man's labor is no longer alienated Marx imagines that social freedom will replace politics as Marcuse believes that erotic freedom will replace sexuality. The object of revolution for Marx, as well as for Marcuse and Sartre, is, then, to achieve human freedom. (The idea of freedom is logically related to the ideas of alienation, repression, and transcendence which are central to their thought.) When they speak of change or, rather, of change in the particular form of revolution, it is not change for its own sake, or change as great as possible, but change with a special object that they have in view. It is for this reason that Braybrooke's proposed readings of "total" change not only fail to make sense of the texts in question but do not constitute a philosophical elaboration of the Hegelianized Marxist tradition's *idée mère* either. When they speak of "total" revolution these writers often mean to make the contrast with merely political revolution, for in their view political freedom certainly does not exhaust, indeed, it does not even guarantee, human freedom. The *bourgeois* is in conflict with the *citoyen* and human freedom therefore requires not only political freedom but economic freedom—and perhaps sexual freedom as well. (Given the abstract way in which these aspects or dimensions of human life are catgorized it does not seem to me to be bizarre to demand freedom in *all* of them.)

Braybrooke seems to me to come much closer to engaging this tradition on a fundamental point when he considers change in the sense of change "in some important condition affecting the whole of society," a sense which he exempts from the charge of extravagance. But he fears that the condition in question may be of a metaphysical or theological sort—"an evil, like sin, that can be

attributed to everyone no matter what the statistical evidence may be." No doubt the concepts in question are vague, but not, I think, hopelessly or irremediably so. Marx suggests some criteria that would show the burden of alienated labor to have been lifted (work is done spontaneously, with pleasure, and not simply to satisfy physical needs). And even Marcuse provides some marks of unrepressed sexuality (disappearance of genital predominance, guiltless enjoyment of the perversions, and of extra-monogamous eroticism). It is certainly true that we are far from knowing whether genital sexuality is, in fact, a consequence of repression and, if so, whether society's need for labor is its cause. Then, too, it is far from plain that overcoming the division and alienation of labor is more important than increasing the production of goods and enforcing their distribution according to more equitable standards. Marx's preoccupation with the problem of alienation and production gives him a special—and I think distorted—view of the problems of labor and prevents him from giving due weight to the problems of distributive justice. This preoccupation with, and excessive emphasis on, the idea and value of freedom in its most attenuated senses and marginal applications seems to me to be the central problem for this tradition of thought; far greater, I think, than the fact that we occasionally find ourselves defined into slavery, indeed, into total slavery.

The Marxist tradition is not, of course, the only one, and those who call for "total" revolution are not the only revolutionaries. I do not know whether the aims of some of these other revolutionaries are sufficiently "specific" to meet the first criterion of "incrementalism" that Braybrooke and Lindblom set down in *A Strategy of Decision*, but they are certainly exempt from many of the faults that Braybrooke finds with revolutionaries in his present paper.[7] The objective of a coup d'etat, for instance, may be as specific as the desire to remove a particular official from office or to alter a particular governmental policy, and yet at least some writers, even some who regard the revolutionary act as a simple violation of fundamental law, and not as the institution of a new "basic

norm," consider the coup d'etat a form of revolution.[8] But, of course, those who attempt a coup d'etat may have more ambitious (although still relatively specific) objectives—a change in the constitution, the modernization of agriculture, the destruction of an obstinate ruling class. These objectives, and certainly objectives more "comprehensive" still, would generally be thought of as revolutionary, and those who attempt coups d'etat with designs like these cannot be guilty of Braybrooke's Fallacy of Proportionate Consequences (according to which only big changes can have important consequences). As Rapoport indicates, the "fulcrum" image is characteristic of coup d'etat literature. (Incidentally, revolutionary imagery offers a far more fruitful topic of investigation than the kind of revolutionary rhetoric that Braybrooke examines —and, I believe, exaggerates. The storm that must burst, the fever that must come to a crisis, and, in the Marxist case, the birth that is inevitably painful, give an invaluable insight into revolutionary psychology and habits of thought.)[9]

But the question whether, and which, coups d'etat count as revolutions is a complex one and it is not necessary to rest the case on them. Plainly, the great territorial-nationalist revolutions[10] were often not "total" revolutions in anything like Braybrooke's sense, nor were the domestic aspects of the English and American Revolutions, revolutions which conservative writers distinguish from the French Revolution (in their view the inspiration of the Hegelian philosophy of history) and from the Russian Revolution (its catastrophic consequence).[11] One of the major points of Gentz's classic discussion of the differences between the American and the French Revolutions is that at every stage of its progress the American revolution "had a fixed and definite object, and moved within definite limits, and by a definite direction towards this object." (Translation by John Quincy Adams.) Whatever we may think of this as history —at best it is idealized—I doubt that Braybrooke wishes to charge Washington or John Adams with displaying the faults he finds in revolutionary thought and speech. I take it that, along with Burke, Gentz, Tocqueville, and Arendt he looks with some favor upon

the principles of the American Revolution. Then, too, if one of the motives of incrementalism is the view that political change ought to be based, so far as possible, on experience, it is worth remembering that the Revolution of 1688 was thought of, at least by some writers, as a revolution in the astronomically influenced sense, i.e., as a restoration.[12]

If the American Revolution shows that it is possible for revolutions to have specific objectives and to limit themselves to something less than thorough-going change it is at least arguable that some reasonably specific changes (preventing any more Vietnams) cannot be brought about without comprehensive, structural, or "total" change. This is, of course, the programmatic objection to programmatic incrementalism. Thus, Braybrooke says that, like Marcuse, he objects to the power of the military-industrial complex (not all that specific, after all) and says that he would like to join hands with those to his left in working against this particular evil. But, as he knows, in Marcuse's view, in order significantly to weaken the power of the military-industrial complex one would have to end the Cold War. In order to end the Cold War one would have to alter a communications system that can impose a belief in the threat of international communism on the masses of the population. In order to do that one would have to break the hold of certain economic interests and ultimately of the capitalistic system which would be subject to the classical Marxian contradictions if the war economy were dismantled. But to do that one would have to change people's belief that they owe the abundance of consumer goods to this system and one would even have to change their taste for the fruits of a waste economy. Until one does all this the masses will perpetuate "the system" politically (the value of democratic freedoms of the sort instituted by the American Revolution is largely illusory) and there is no more powerful way to institute majority irrationality than by majority rule.[13]

Now Braybrooke may take the view that this analysis and all such analyses are and must be wrong or unintelligible, which I do not suppose he would say, or else he must face these alterna-

tives. Either he must say that an incrementalist attack can always succeed (and succeed in morally good time) in effecting the "comprehensive" or "total" change that is required or he must say that at a certain point he is prepared to abandon incremental methods for more revolutionary ones. His disagreement with those more radical than he will then be about the facts, and the moral date, and not about the legitimacy of certain styles of thought and action. Braybrooke's view on this matter is difficult to determine from his paper and, especially in view of his earlier collaboration with Lindblom in *A Strategy of Decision*, it would be interesting to know his present views.

One of the difficulties of such a discussion will be, of course, to establish the criteria of revolutionary, as opposed to incremental (and, one hopes, some other kinds of) change. (Or is incrementalism to become a metaphysical or theological good, like grace abounding?) For if Braybrooke is willing to contemplate vast change if it is achieved incrementally (as his final remarks suggest) the criteria of revolutionary, or at least of non-incremental, change will have to lie in its abruptness, its illegality, possibly in its violence. Due to his emphasis on the "totality" of revolutionary change he has neglected these, perhaps more crucial, aspects of the concept of revolution.

For myself, I believe that when the fundamental principles of liberty and justice have been plainly and persistently violated revolutionary action (in all the above senses) is justifiable, only assuming that it is rational to believe that these actions will not visit worse evils on the population than they are intended to cure. The requirements of liberty and justice must always be interpreted with respect to the historical circumstances in which they are to be applied but, in something like modern Western circumstances, these principles require national independence and universal participation in the political life. On these grounds I have no doubt that the great modern national and democratic revolutions were justifiable. It is also my conviction that the principles of justice require, at least, that the needs of all should be satisfied before the

preferences of some are indulged. This is to say that revolutions may legitimately seek to answer the "social" question. It is, of course, the view of many conservative writers like Tocqueville[14] (next to Marx the greatest theorist of revolution) and of so distinguished a contemporary writer as Hannah Arendt[15] that any revolution which attempts to liberate men not only from tyranny, but from necessity as well, is condemned to ideology and terror (inner and outer compulsion). Such views merit the most serious consideration, but they do not seem to me finally persuasive on either factual or moral grounds. Finally, the principles of justice between nations, characteristically expressed in international agreements and treaties, and often accorded constitutional status, must be observed. Where the democratic and constitutional stage has been reached I believe that anyone who has rational grounds for believing that these principles have been violated has a duty to bring constitutional test cases (where this is not hopeless) before taking more serious measures.[16] (Constitutions often embody the principles established in earlier revolutions and their pertinent interpretation may obviate the need for future ones.) But if these appeals, the one in the courts, the other to the public conscience, should fail, illegal, and even violent, actions will in certain circumstances be justified. I do not reject the view that we find ourselves in such circumstances.

NOTES

1. K. Marx and F. Engels, "Manifesto of the Communist Party," *Marx and Engels, Basic Writings on Politics and Philosophy*, ed. L. Feuer (New York, 1959), pp. 24–26.

2. K. Marx, *Capital I*, in *Karl Marx: Selected Writings in Sociology and Social Philosophy*, ed. T. B. Bottomore and M. Rubel (Aylesbury, 1963), p. 259.

3. H. Arendt, *The Human Condition* (Garden City, 1959), pp. 90–91; contrast S. Avineri, *The Social and Political Thought of Karl Marx* (Cambridge, 1968), pp. 236ff.

4. K. Marx, *The Poverty of Philosophy*, Bottomore and Rubel, p. 244.

5. R. Miliband, "Marx and the State," *The Socialist Register 1965*, ed. R. Miliband and J. Saville (New York, 1961), p. 292.

6. H. Marcuse, *Eros and Civilization* (New York, 1961), especially pp. 34, 37, 81, 180ff.

7. D. Braybrooke and C. E. Lindblom, *A Strategy of Decision* (New York, 1963), p. 74.

8. H. Kelsen, *General Theory of Law and the State* (New York, 1961), pp. 117, 219ff, 368f., 372; compare H. L. A. Hart, *The Concept of Law* (Oxford, 1961), pp. 114–15.

9. D. C. Rapoport, *"Coup d'etat*: The View of the Men Firing the Pistols," *Revolution: Nomos VIII*, ed. C. J. Friedrich (New York, 1966), p. 66n.; C. Brinton, *An Anatomy of Revolution* (New York, 1965), pp. 14–20.

10. Ibid., p. 24.

11. F. Gentz, "The French and American Revolutions Compared," in F. Gentz and S. F. Possony, *Three Revolutions* (Chicago, 1965), p. 67.

12. A. Hatto, "Revolution: An Enquiry into the Usefulness of an Historical Term," *Mind* (1949), pp. 504–6. H. Arendt, *On Revolution* (New York, 1965), p. 36. But compare M. Seliger, *The Liberal Politics of John Locke* (London, 1968), pp. 320–23 for a critique of the work of E. Rosenstock-Huessy and of K. Griewank on which Arendt and many other scholars rely.

13. H. Marcuse, *One-Dimensional Man* (Boston, 1964).

14. A. de Tocqueville, *The Old Regime and the French Revolution* (New York, 1955); de Tocqueville, *Democracy in America* (New York, 1945); M. Richter, "Tocqueville's Contributions to the Theory of Revolution," Friedrich, op. cit., pp. 75–121.

15. H. Arendt, *On Revolution* (New York, 1965).

16. See M. Cohen, "Civil Disobedience in a Constitutional Democracy," *The Massachusetts Review* (Summer 1969), and the acknowledgments there to R. Dworkin and J. Rawls.

Reply

DAVID BRAYBROOKE

1. Professor Cohen doubts "whether any historically significant revolutionary thinker can be interpreted as proposing Total Change" in any of the senses that I attack as extravagant. If what Cohen has in mind is the net balance that judicious interpretation might strike in surveying the whole of the doctrines of any such thinker, and their development through the thinker's lifetime, I have no mind to dispute him; I explicitly said that I was isolating one theme—one theme among others with different tendencies—and exaggerating it beyond the point of caricature. I freely acknowledge that the approach of my paper in clarifying revolutionary thought has much in common with the search technique of the drunk in the old story, who lost his wallet up the street, but looks for it around the lamppost because the light is brighter there. The figure needs to be varied only slightly, however, to make my purposes fairly respectable. It happens that it is easier to set up a bright philosophical light on the periphery of revolutionary thought, where the concept of total change bloats with extravagances; and I think the light shines some distance toward the center of the field.

2. If Cohen's doubts extend to the presence of "total change" as one theme among others, subject to extravagant interpretations, then we do disagree; and I think he is quite mistaken. I think that he has not really faced up to the absurd tendencies present in my citations—especially the chief one from Marcuse and the parallel one from (the young) Marx. The citations I gave in my paper can, moreover, be multiplied. Marcuse says many other things (some of which Cohen has very elegantly recounted), and he is a serious revolutionary thinker; but he does indulge himself time and time

again with the theme of total change (as Cohen seems to admit at one point in his remarks).[1] He is looking for "a total rupture,"[2] which will not merely tear past political changes to rip out some social ones: "Il s'agit d'une totale conversion des valeurs."[3] "The young middle-class opposition," of which Marcuse approves, has "common ground," he says, with "the black rebellion," which he also condones, in "the total rejection of the existing society, of its entire value system."[4]

According to Marcuse "the New Left" opposes "the entire organization of the existing liberal-parliamentary democracy"[5] and he says that these rebels—with whom he aligns himself—find "the democratic process organized" by the present "power structure . . . discredited to such an extent that no part of it can be extracted which is not contaminated."[6] Here is an instance ("contamination") of the revolutionary imagery that Cohen rightly finds fascinating. But what reasons could Cohen have for inferring that in comparison it is hardly fruitful to examine the rhetoric of total change? There is perhaps not so much fun for the literary critic; but may not the rhetoric have its own commensurable importance, and clarifying it be a suitable task for philosophical analysis? Besides, I am not sure that the concept of "total change"—a metaphor of Heraclitean flux—is not itself used figuratively by thinkers like Marcuse; and in the present instance clearly there is potent imagery (medical and theological combined) behind it, driving it to renewed extravagances.

3. I say in my paper (perfectly reasonably, and in full accord with advanced thinking in the social sciences) that institutions may be defined as complexes of norm-properties; and by treating them this way I indicate how they are exposed to attacks mounted upon the "entire existing value system." Such a value system would surely embrace attachment to the existing institutional norms or rules; and expectations of reward and punishment associated with these rules.

Nevertheless, there is a weakness in the way I handled this approach to defining institutions; and Professor Cohen has touched

upon it in his remarks on the second criterion or demand that I lay down for the most extravagant sense of total change. I do not agree with his remedy for the weakness; or find his references to Marx's actual doctrines about the family especially relevant; but I must do something to reconstruct my exposition in the passage that he objects to.

In my example of the family as an institution to be affected by total change, I say, first, "The family in our society may be defined by citing norms that permit men and women to pair off permanently and that oblige them (with certain exceptions) to live together once paired and provide for their children." When I say, several paragraphs later, that it would not suffice to eliminate something recognizably like the present institution of the family merely to change into their opposites the rules obliging parents to provide for their children or permitting wives to go out to work, it may well look (as it evidently has looked to Cohen) as if I had forgotten that the essential, defining norm-properties of the family would be changed, too, if (according to my first demand) every norm-property of the institution changes into its opposite.

Why go on to demand as well that the institution must not survive "even as a locus of norms; there must be no institution" afterwards that "uniquely corresponds" to it? But in fact something can be said (which regrettably I did not say) to justify imposing this second demand, both as regards the family and generally.

If we turn back to the norms that I cited as figuring in the defining properties of the family, we can see that possibly even they can be changed into their opposites and leave something like the family standing. Suppose the rules permitting men and women to pair off permanently were changed to a rule obliging them to part after a dozen years. If the latter can be counted as the opposite of the existing rule, then clearly something like the family could survive even if it is brought into force. If obliging them to part after a dozen years does not count as the opposite, one might consider a more radical change to a rule obliging men and women to part (desist permanently from sexual cohabitation) after the women be-

came pregnant. The family might then take on a drastically matriarchal cast; but there might still be an institution like the present family in important respects. So the need for the second demand can be made plausible even in my particular example.

However, I think the truth of the matter, generally speaking, is that whether the second demand is needed or not (by the concept of total change at this extreme of extravagance) is indeterminate. It might be the case that if every norm-property of any given institution were tracked down and changed to its opposite, nothing like the institution would survive; but I do not know how this exhaustive procedure could be carried out (because the number of norm-properties found depends on the ingenuity of the observer), or be proved to have been carried out. Given this ignorance (which seems to be inevitable) the second demand has a claim to our attention as a precaution (if I may so speak) which extravagance needs to take in order to make sure of any contemplated social change being as total as possible.

4. A much more important weakness in my paper, which thanks to Cohen and other participants was brought to light in the discussion at Oberlin, was the mistake I fell into of treating revolution and incrementalism as logically opposed approaches to social change. Now (as the concluding paragraph of my paper indicates) this mistake consists in part of an inconsistent deviation from my own previous and current understanding of incrementalism. In *A Strategy of Decision*[7] Lindblom and I envisage the possibility that a succession of incremental changes might be carried through very quickly;[8] and the rapidity and cumulative importance of the changes might well deserve in some such cases to be called "revolutions." But my mistake also reflects an oversight. I do not recall that Lindblom or I ever contemplated the possibility of violence being necessary to effect an incremental change; but I see now that such a possibility—a variation in methods—is compatible with desiring (in some given instance) only an incremental change. In such an instance an incrementalist such as I might, after weighing consequences, endorse a demonstration liable to provoke violence from

others (e.g., the police) or even the initiation of violence from the side desiring change.

One might wonder whether incrementalism would suffice for reform or progress in a society in which incremental change called for violent means in many or most instances. But then neither Lindblom nor I nor the other thinkers who have found some rational merits in incrementalism, when it works, have claimed (so far as I know) that it always does work. We would be inclined to say that a society in which it does not work is in a desperate condition; but saying that would not differentiate us from revolutionists.

5. Is the United States in that desperate condition now? I am not ready to say so; I do not think the people who might join in attacking the military-industrial complex have by any means come close to exploiting the full opportunities for non-violent action whether incremental or not. I specified my target with the phrase made familiar by Eisenhower just because its currency suggests how many more people might be ready to join in the attack; the target can easily be specified more exactly (as, e.g., the Pentagon plus the CIA plus those firms more than, say, 25 percent of whose profits derive from sales to the Pentagon or to the Space Administration, together with the organized interest groups in which those firms predominate). But what has been done to rally those people for sustained action against this target? How many opponents of the military-industrial complex have resolved to work for at least half a dozen years in their local Democratic committees, seeking the sort of control over the Democratic Party that the Goldwaterites obtained over the Republican Party in 1964? How many have come anywhere near responding to Szilard's original appeal for 1 percent of their annual income to support pressure groups like the Council for a Livable World? I am not sanguine about the future of incremental reform in the United States; but I am even less sanguine about the chances of a sudden, violent, "liberating" revolution; and at least for the time being I do reject the view that we find ourselves in circumstances so desperate as to call for an attempt at such a revolution.

NOTES

1. See p. 121.
2. H. Marcuse, "Liberation from the Affluent Society," in David Cooper, ed., *The Dialectics of Liberation* (London, 1968), p. 177.
3. H. Marcuse, "Réexamen du concept de révolution," *Diogène* 64 (Octobre-Décembre 1968), p. 29.
4. H. Marcuse, *An Essay on Liberation* (Boston, 1969), p. 58.
5. Ibid., pp. 62–63.
6. Ibid., p. 63.
7. New York, 1963.
8. Op. cit., pp. 106–10.